Horse

Horse

THE HORSE AND IRISH SOCIETY

DAVID O'FLYNN

The History Press Ireland

'If I knew how to take a good photograph,
I'd do it every time.'

Robert Doisneau

First published 2011

The History Press Ireland
119 Lower Baggot Street
Dublin 2
Ireland
www.thehistorypress.ie

British Library Cataloguing in Publication Data.
A catalogue record for this book is available from the British Library.

ISBN 978 1 84588 706 3

Typesetting and origination by The History Press
Printed in China

Contents

Acknowledgements

First and foremost I would like to thank all those I photographed in the making of this book. I have encountered extraordinary generosity and kindness over the course of this project and this book is not only about you, it is for you.

I would like to express my profound appreciation to Mickey and Tara Gerbola; Julia Kuehnle; John Carey and the Gardaí of the Mounted Unit, especially Julie Folan, Nives Caplice, Conor Bangham and Denis Farrell for allowing me to photograph while they worked. I would also like to thank the staff at the Dublin Horse Show, Laytown Races, the Curragh Racecourse and the Galway Racecourse for granting me access to photograph their events. I would like to offer my sincere thanks to Stephanie Boner and Ronan Colgan at The History Press Ireland for their encouragement and for seeing the potential in this, my second book project. I would also like to thank Darragh Shanahan in the Gallery of Photography for his advice.

My heartfelt thanks also to Brid Danaher, for providing a home away from home at various stages over the course of this project. Only for you it would have been far more difficult for me to complete this book.

In all certainty this book would not have happened were it not for the love and patience shown to me by my family. It's not possible for me to adequately express my gratitude to my children, Aoife and Maeve, for indulging what can at times be an all-consuming passion. Above all I would like to thank my wife Helen for her enthusiasm for my photography and especially for her love and support in everything I do.

Introduction

I can trace the inspiration for this book back to two separate events that I briefly and accidently attended in late 2008. I had been taking photographs in a windswept graveyard overlooking the Atlantic Ocean in Waterville, County Kerry. On my way back I stopped in Killorglin, where a small horse mart was just finishing in the market yard. It was raining heavily and I was tired and wet. After walking around the market for a few minutes I decided to get a coffee in a nearby café. It was the type of place that doesn't have a full set of matching crockery, but it was clean, reasonably priced and serving real, 'meat and two vegetable' dinners. As I sipped my coffee I watched the people coming and going, and those sitting at tables, most of whom had been attending the market. The diversity of the small groups at the different tables really struck me, as it directly contradicted my preconceptions of the type of people who would attend something like this. In my ignorance, I wouldn't have expected to see many women at a horse market (I don't know why I thought this, as women are just as likely to own and ride horses), but there were women at every second table. There were families with young children dressed for the weather, complete with colourful wellingtons, old men who have probably attended this market for years, and younger people from far and near who were there to buy and sell horses. It was clear to me that the people in the café were from all sections of society. Besides a religious pilgrimage, it was difficult for me to think of any other circumstances where such a varied group would gather together.

A few weeks later I was at the start of the Christmas hunt in Knocakaderry, which is a small village in County Limerick. For 200-300 metres there were all manner of cars, vans, horseboxes, 4x4s and trucks parked along the edge of the road leading into the village.

It was a crisp morning and it was turning into a pleasant, if slightly cold, winter's day. I spent about half an hour wandering amongst the people on their horses, watching them riding up and down the road in their clean and neatly pressed riding gear, getting ready for the hunt. For the second time in a few weeks I found my preconceptions about the type of people at equine events being forcibly challenged. I hadn't appreciated how big hunting is in Ireland and I always thought that it was an elitist pastime. However, this clearly wasn't the case and, yet again, I was struck by the way that the hunters came from all walks of life. I was also surprised to see how young some of the children taking part were, in full riding gear, with their horses saddled up and ready for the off.

The idea for this book evolved from thinking about these two events over the subsequent weeks. I was certain that there was an interesting project there, if I could only define it. I kept thinking about the people I had come across, and how this seemed to be a uniquely Irish thing. The different social backgrounds of the people attending the events were apparent. Ireland, even with the demise of the Celtic Tiger, is changed, and yet clearly the horse still has a place deep in the soul of the Ireland of today. It is part of Ireland and part of what it means to be Irish. I decided to try and capture a flavour of the cross-societal nature of the love and affection the Irish have for horses. While horses would be the common thread, this project was going to be about us, the Irish people (and I mean the Irish people in its widest context). I decided that rather than a series of picture-postcard-style images, the photographs should reflect the reality of what I found. Some aspects of this have been the subject of photographic essays before. There are some wonderful photographic projects dealing with inner city kids and their ponies and there have been

many, many racing and show-jumping books published. While I knew that this project would intersect with this other work to some extent, I wanted to look at this theme in a new way.

In starting this project I had to face up to one significant handicap: I knew virtually nothing about horses. I had never owned a horse, I didn't attend race meetings and I had no interest in betting. I wasn't sure where the best place to start would be, so I decided I may as well begin close to home. For this reason, I decided go to the horse market in Smithfield. I didn't know much about the market other than that it is held on the first Sunday of each month and that Dublin City Council had made a couple of unsuccessful attempts to close it down. I was also vaguely aware that some animal welfare organisations had expressed concern over the treatment of the horses at the market. My recollection was that the old square was rundown, grimy and empty. However, modern Smithfield has a vibrancy that is enhanced by the colour and character of the horse market. There were horses of all sizes, from those that were no bigger than large dogs to great, majestic horses towering over the heads of the people present. The small Garda presence was mainly concerned with keeping all the horse-related activity on the cobbles in the centre of the square, and off the roads and paths. Anything went, and horses were being raced, trotted and walked in all directions. A farrier was kept busy most of the morning, shoeing horses, and there were a few vans selling saddles, bridles, reins and harnesses. There were people of all ages attending and many of those buying and selling were children. There was a friendly atmosphere and the event seemed to be as much a social occasion as it was an opportunity to trade.

Next I went to the Dublin Horse Show in the RDS and the contrast with Smithfield came into sharp focus. When I was growing up, going to the Horse Show was an annual pilgrimage for us and many other Dublin families, but I hadn't been to it for many years. At the time, riders like Eddie Macken and Paul Darragh were among the few international sports stars that Ireland had. The memories of being in the crowd on a couple of the occasions that Ireland won the Aga Khan Trophy in the late seventies came flooding back as I walked around the main show-jumping ring again. On my first morning there I took the shuttle bus from the designated car park to the RDS. The driver smiled as I boarded the bus and when I looked down at the passengers I immediately realised why; my first thought was that I had wandered into to the middle of an Orange Lodge outing. The bus was filled with men wearing smart dark suits, white shirts and bowler hats. In the years since I had last been to the Horse Show I had forgotten how formal the attire was for officials on duty. There were good crowds attending and, possibly due to nostalgia, I was glad to see that it still seemed as popular as ever. The contrast between Smithfield and the Dublin Horse Show was marked; I knew that the idea for this project was strong and that there was ample potential for producing a relevant and interesting collection of photographs.

Just how big is the Irish fixation with horses? The equine industry is reckoned to be worth over €1.5 billion to the Irish economy and there are more horses per head of the population in Ireland than anywhere else in Europe (27.5 per 1,000 of the population or over 110,000 horses in total). There is a distinction to be made between thoroughbred horses and sports horses. The value of the 40,000 thoroughbred horses to the Irish

economy is €1.1 billion, which is mainly from races, stallion nomination fees and training fees. Over 22,000 people are employed in the industry, and remarkably, a third of these are employed in betting. There are 600 jockeys, nearly 800 trainers and another 4,000 people working in the stables and training yards the length and breadth of the country. Over 1.4 million people attend races annually, and racing festivals are worth €260 million to local economies. Over 80,000 people travel to Ireland annually specifically to attend race meetings.

There are another 70,000 horses in Ireland involved in other activities. The sport horse element of the industry is worth almost €400 million to the economy, mostly from riding schools/centres, leisure yards and breeding. There are also over 50,000 people involved with sports horses at various levels. Hunting remains a popular equine pastime, but the centre piece of the sports horse calendar is undoubtedly the annual Dublin Horse Show. This is nearly 150 years in existence and has developed into a huge sporting and social occasion in the years since the first event was held on the lawns of Leinster House. Irish horse fairs are colourful and remarkable events, with a unique spirit and charm. They exist in a grey, unregulated part of the equine world but they are as relevant to Ireland and its heritage as the Irish language and Gaelic Games.

The place of the horse in Irish life is well established. It is interwoven with other influences to create 'the Irish culture' and is part of our personality as a society. The statistics and numbers alone cannot adequately explain it, and events celebrating the horse have long been traditional in Ireland. For the uninitiated like me, this world is a contradictory mix of the elegant and the bizarre. With a turn of the head a scene can move from the majestic

to the strange (in all forms of that adjective: odd, surprising and unfamiliar). This is also a story of social ritual and behaviour. Every week there are equine events up and down the country, ranging from race meetings to show jumping to hunts and to fairs, and each event attracts its own particular crowd with their own idiosyncrasies. It was not possible to go to every event and so the places I chose for this project were those that interested me most, from either a social or historical perspective.

While this work is by necessity both selective and partial, I do hope that is also fair in its portrayal. I hope that it captures the present-day spirit of this tradition, as well as the contrasts between the different elements that make up this part of Irish culture. The photographs are sometimes documentary, sometimes satirical, sometimes cliché and occasionally eccentric. After all, this is the reality of what I found. Robert Doisneau said that photographs are like snatches from eternity, a 200th of a second here, a 100th of a second there. Even though this project took a year to complete and involved travelling over 8,000 kilometres, the total exposure time for all the photographs in this book (my snatches from eternity) probably amounts to less than a second; a mere heartbeat in which I have tried to capture an honest flavour of the different strands of this great Irish love affair, and perhaps provide a glimpse into our national soul.

Ride On

John Steinbeck observed that 'A man on a horse is spiritually as well as physically bigger than a man on foot.' Portraits of great generals and emperors frequently depict them at the scene of a noteworthy victory on horseback. Horse racing is called 'the sport of kings', and, on a more day-to-day level, a person on horseback will generally attract a kind of respectful attention. The rider is king of all he surveys. This is equally true for the winner of the Irish Derby and the kids riding horses barebacked at horse fairs.

The photographs in this collection were taken at many different locations and at events both large and small. They portray the connection between the rider and horse, and their command of their environment. These environments range from the big events, like the Dublin Horse Show and the Irish Derby, to the smaller ones, such as the point to point meeting in Stradbally Hall in Laois, complete with the elegant manor house and the sounds of a steam engine from the woods bordering the racetrack. There are contrasting events, from the Laytown Races, a unique feature in the Irish racing calendar as the only regulated races held on a beach, to flapper racing in Dingle, which is an unregulated form of racing featuring jockeys aged as young as ten or eleven.

Some of the horse fairs are so old that their exact origins are lost in the midst of time. They are generally organised by local committees and are not regulated. There is an underlying feeling that even if these events weren't organised, they would probably happen anyway. At events such as Puck Fair, the livestock markets have become secondary to the myriad of entertainment and other activities. Others, like the fairs in Spancilhill and Ballinasloe, still seem to retain more than a passing respect to their past traditions. The monthly market in Smithfield has a slight edge to it because of the constant criticism it receives and the attempts to either permanently close it down or move it to another site. There are also still many horses in Ireland working on a day-to-day basis. The horses and riders are varied, yet combined they give this unique part of Irish life a vibrancy and a richness in character.

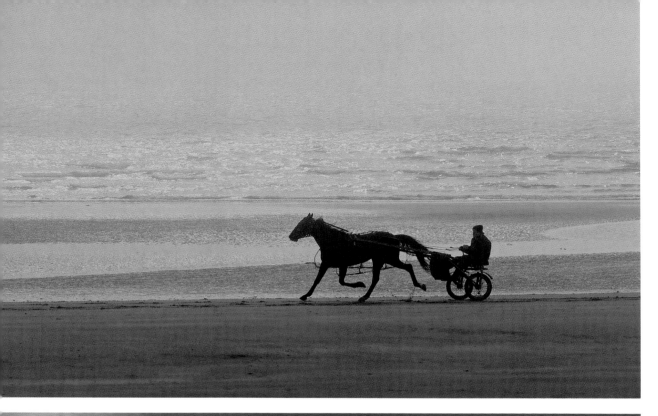

Portmarnock Strand, County Dublin.

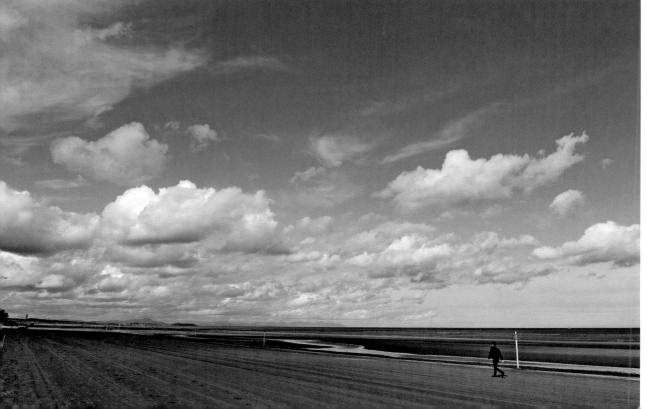

Laytown Races, County Meath.

Opposite: Point to Point, Stradbally Hall, County Laois.

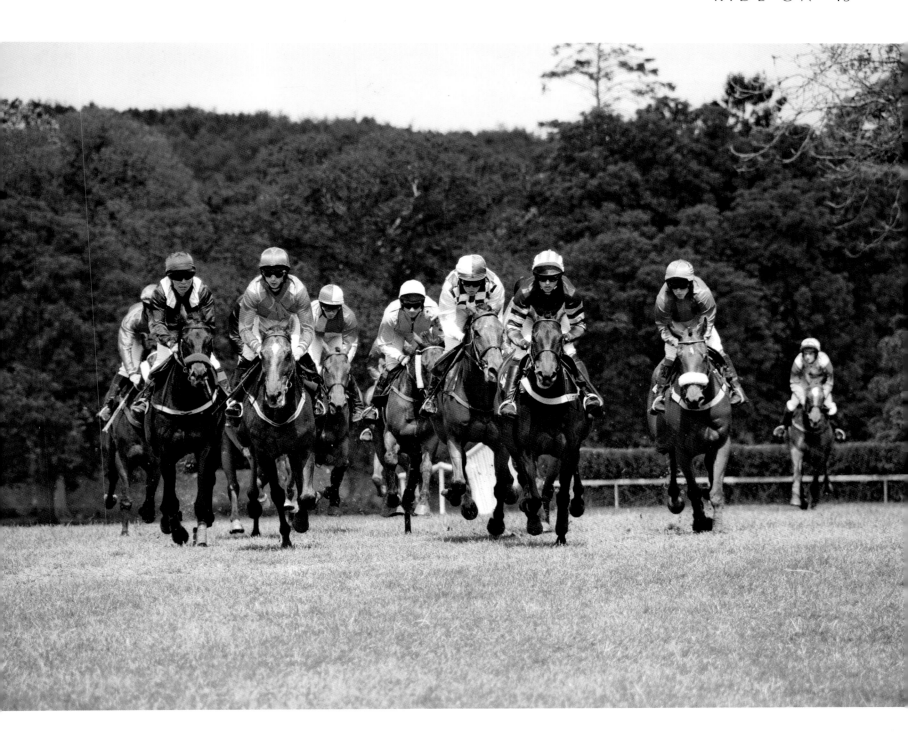

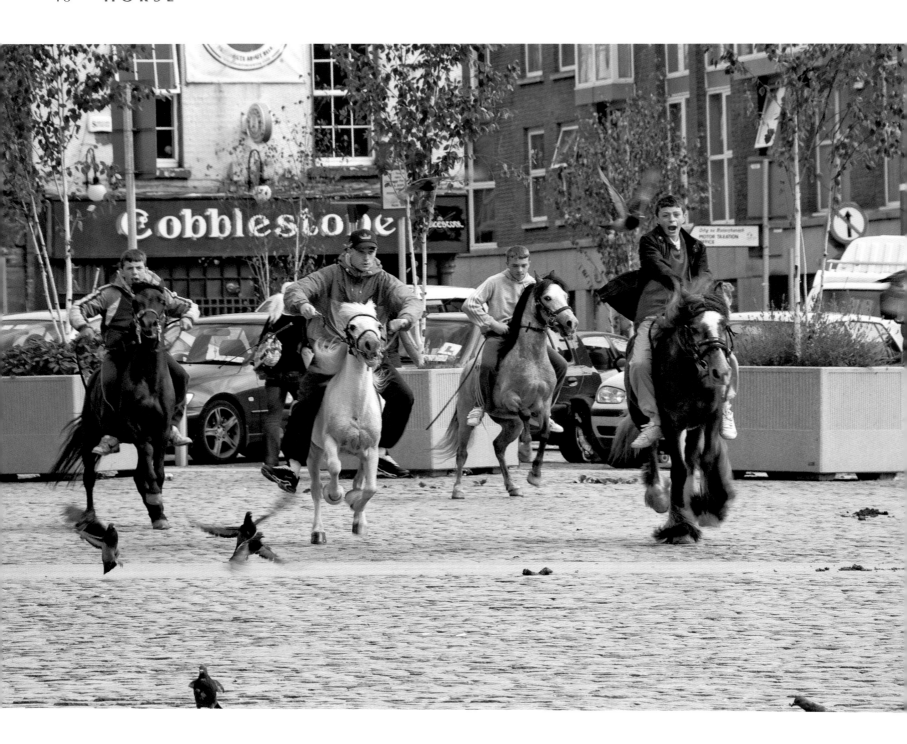

Opposite: Horse Market,
Smithfield, Dublin.

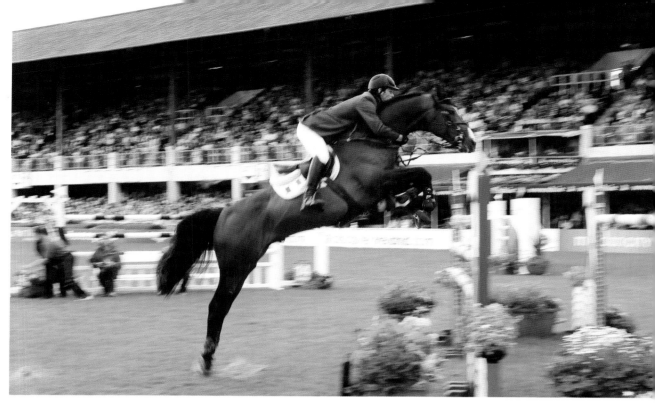

Dublin Horse Show, RDS,
Dublin.

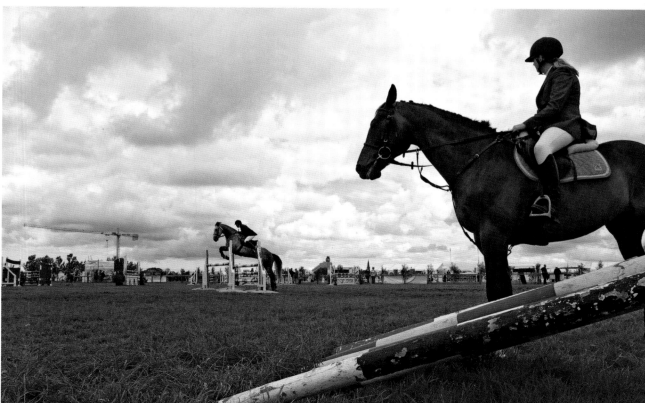

Ballina Agricultural Show,
County Mayo.

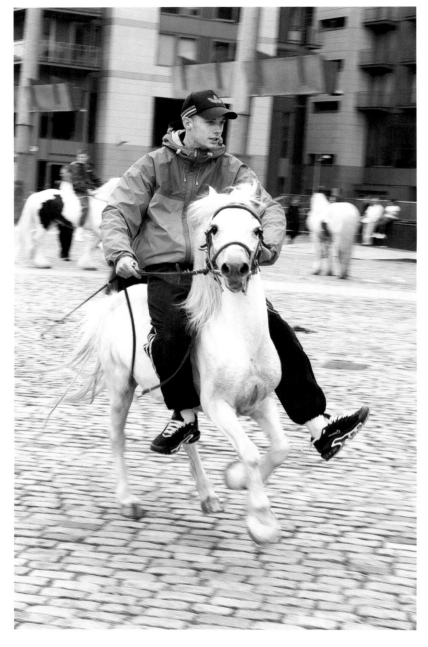

Horse Market, Smithfield, Dublin.

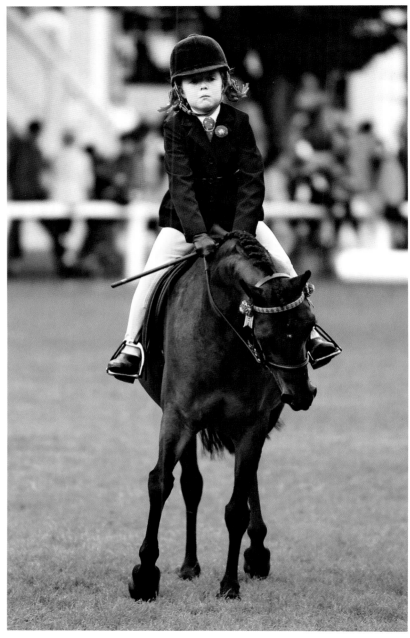

Dublin Horse Show, RDS, Dublin.

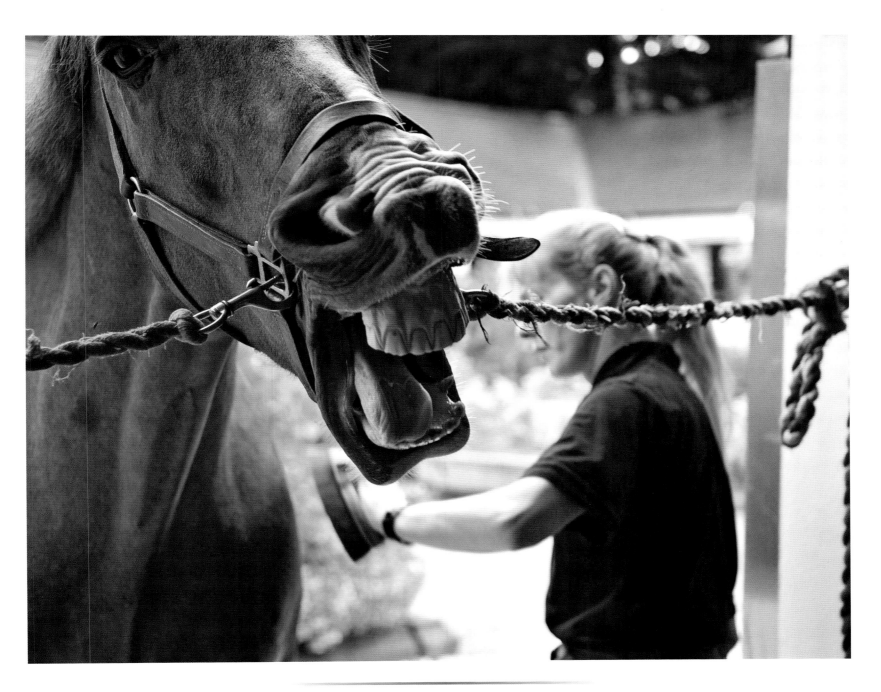

Garda Mounted Unit Stables, Phoenix Park, Dublin.

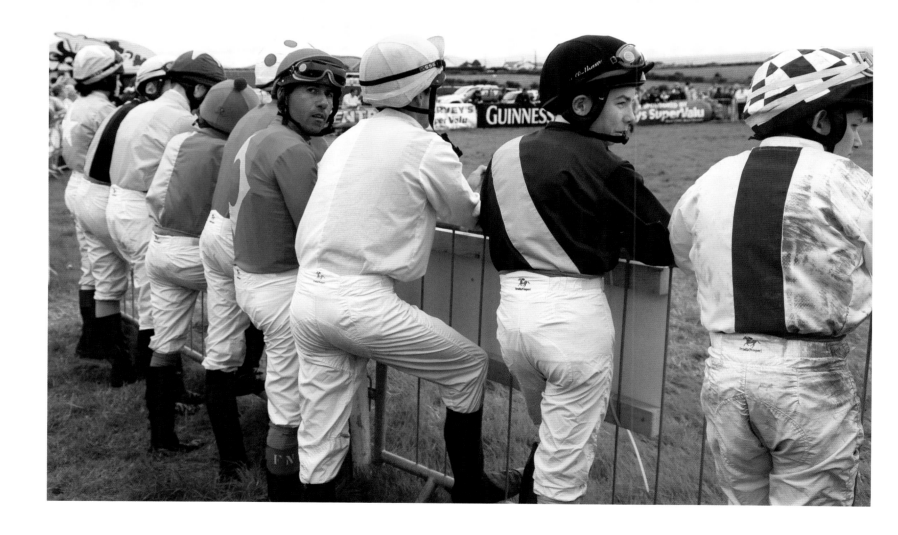

Flapper Races, Dingle, County Kerry.

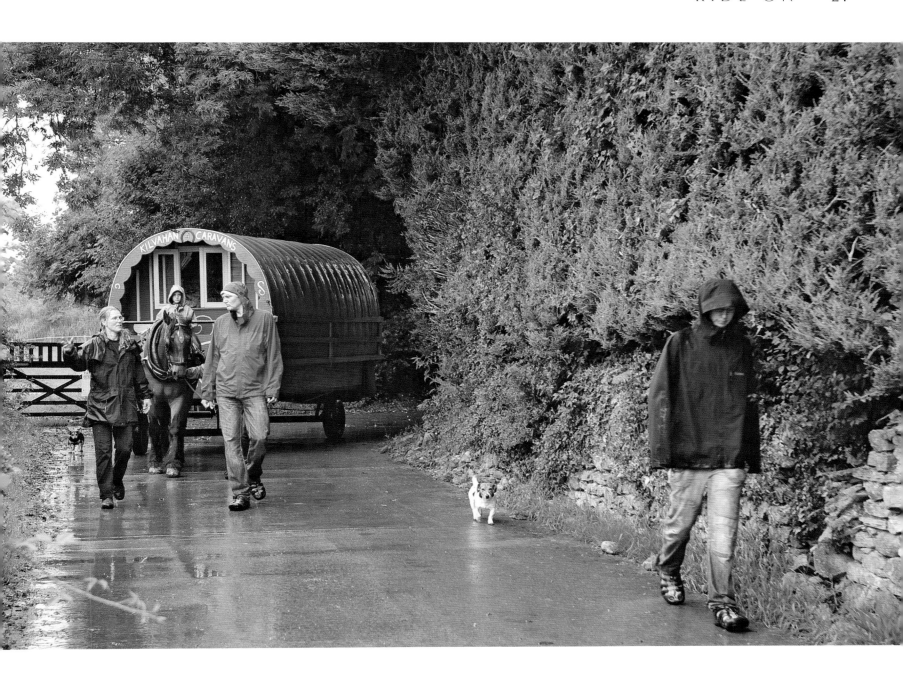

Kilvahan Carriages, Coolrain, County Laois.

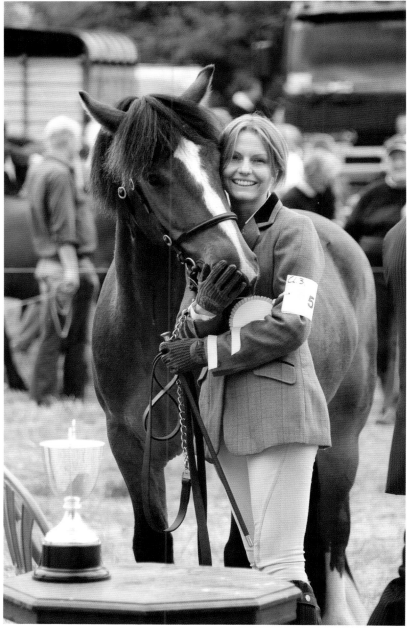

Irish Derby Festival, Curragh, County Kildare.

Horse Fair, Spancilhill, Ennis, County Clare.

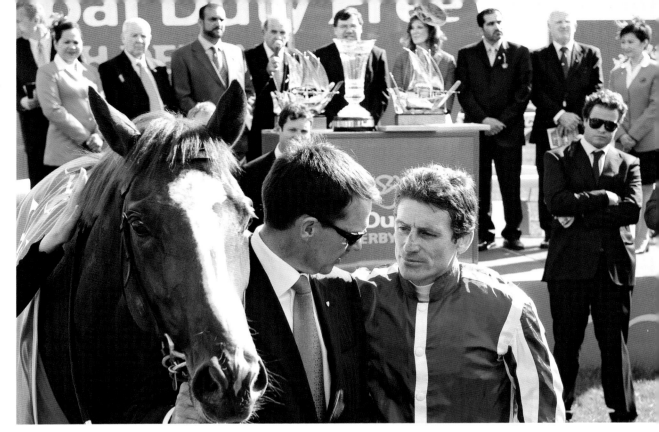

Winner of Irish Derby,
Curragh, County Kildare.

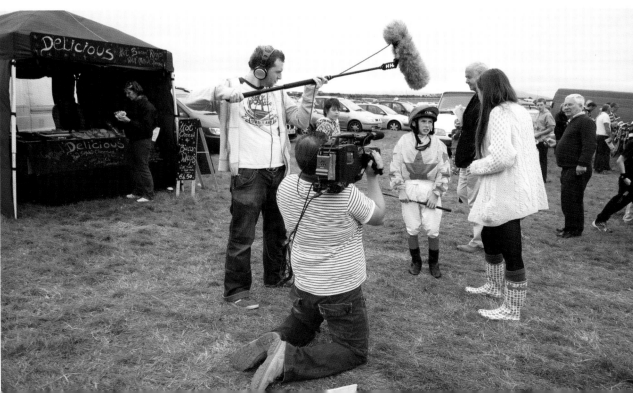

Winner of Flapper Race,
Dingle, County Kerry.

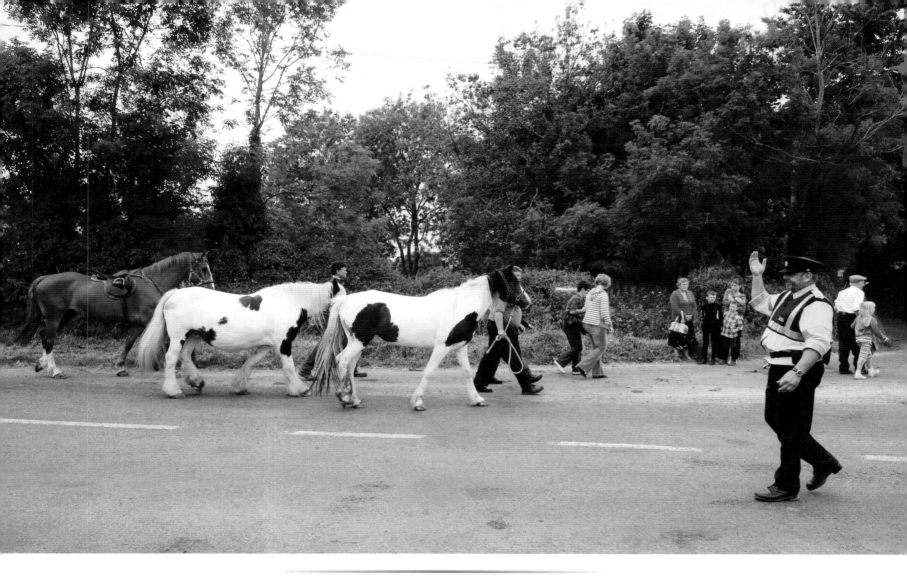

Horse Fair, Spancilhill, Ennis, County Clare.

Opposite: Gap of Dunloe, County Kerry.

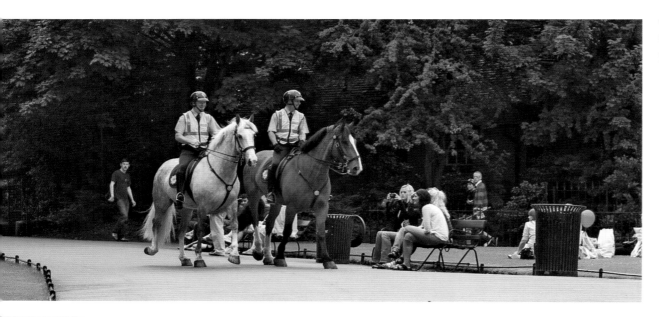

Garda Mounted Unit, St Stephen's Green, Dublin.

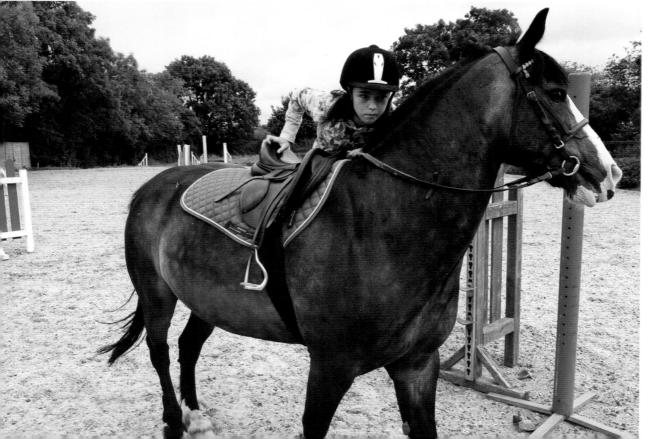

Kinsealy Stables, County Dublin.

Opposite: Horse Market, Smithfield, Dublin.

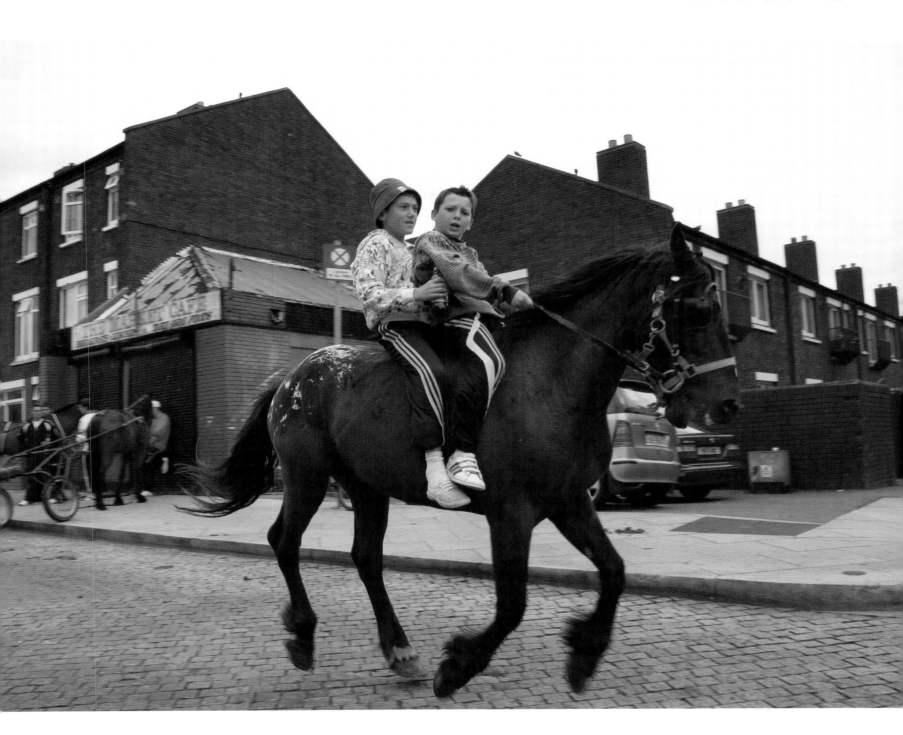

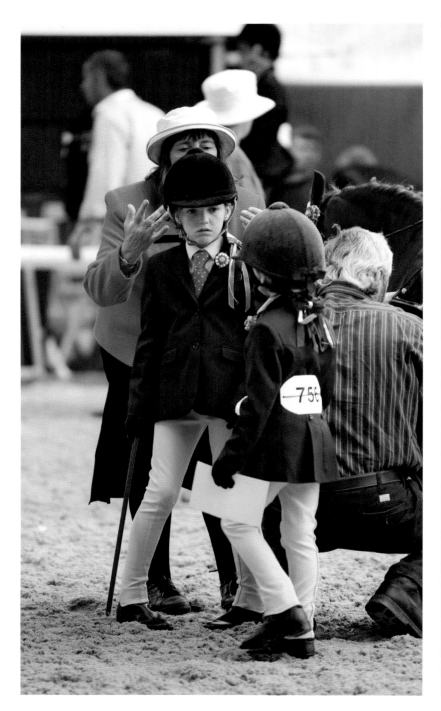

Left: Dublin Horse Show, RDS, Dublin.

Below: Point to Point, Stradbally Hall, County Laois.

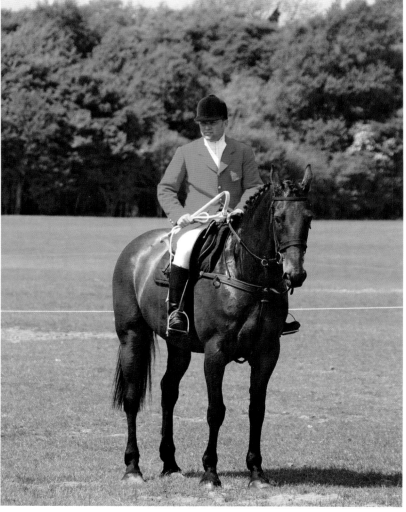

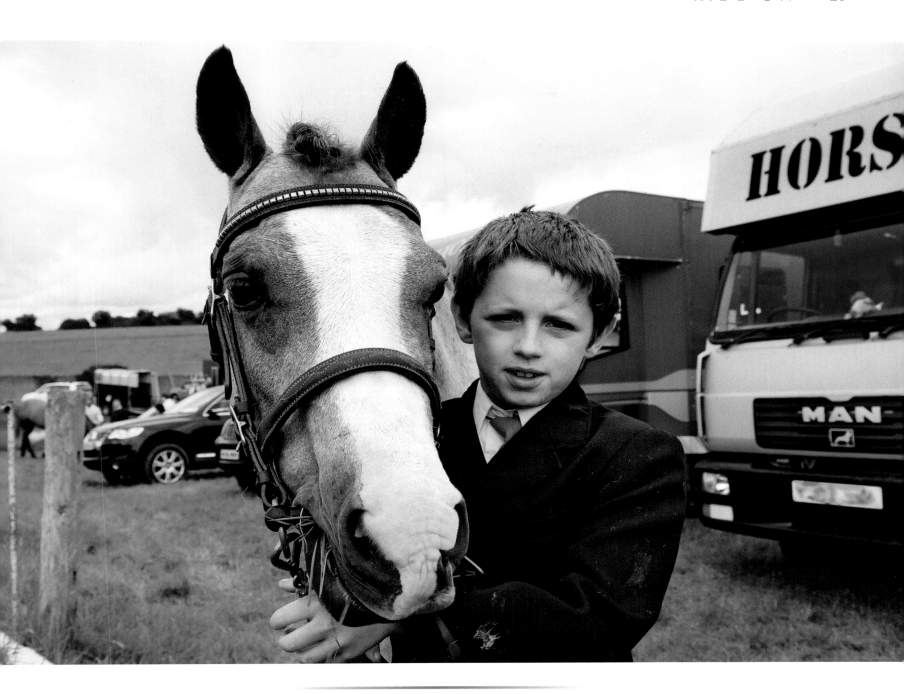

Ballina Agricultural Show, County Mayo.

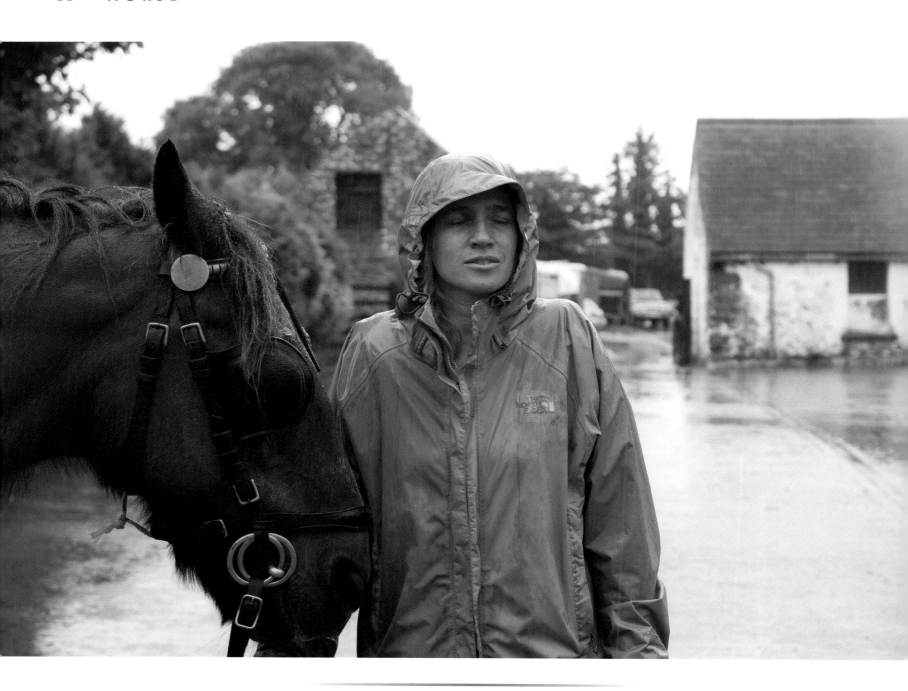

Kilvahan Carriages, Coolrain, County Laois.

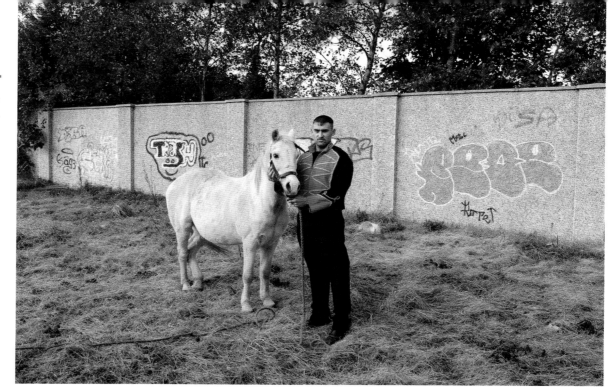

Circus Gerbola, Swords,
County Dublin.

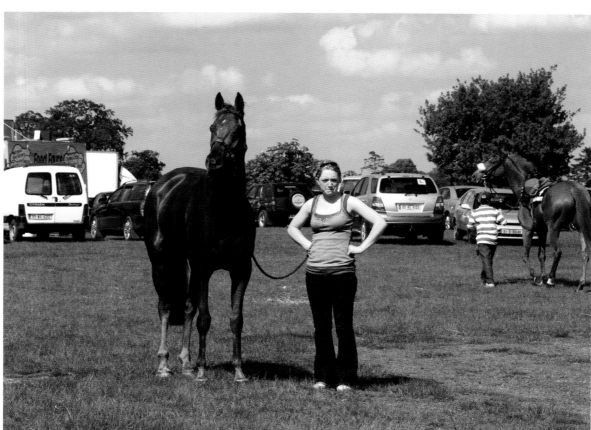

Point to Point, Stradbally Hall,
County Laois.

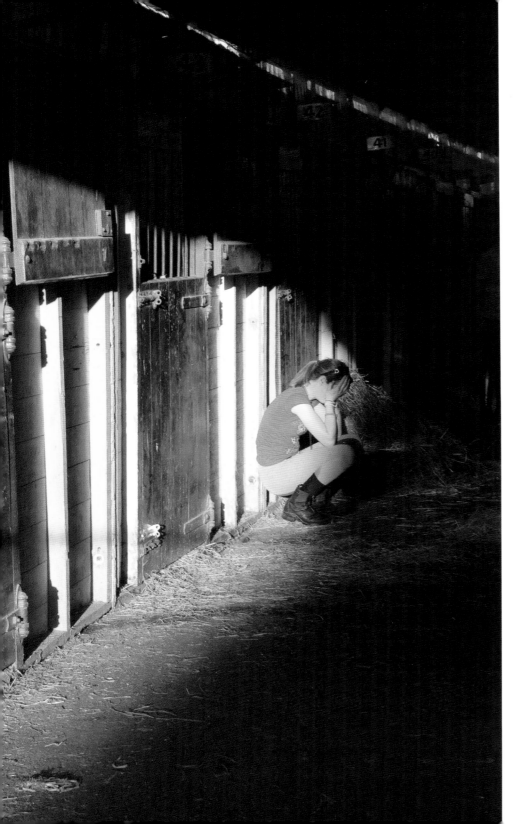

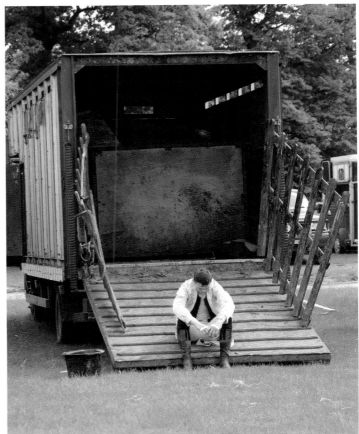

Above: Point to Point, Stradbally Hall,
County Laois.

Left: Dublin Horse Show, RDS, Dublin.

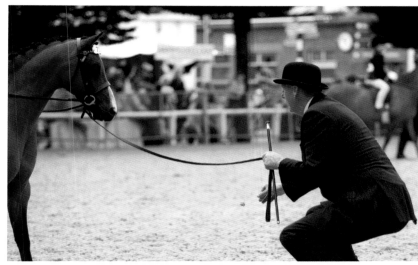

Left: Dublin Horse Show, RDS, Dublin.

Below: Horse Fair, Spancilhill, Ennis, County Clare.

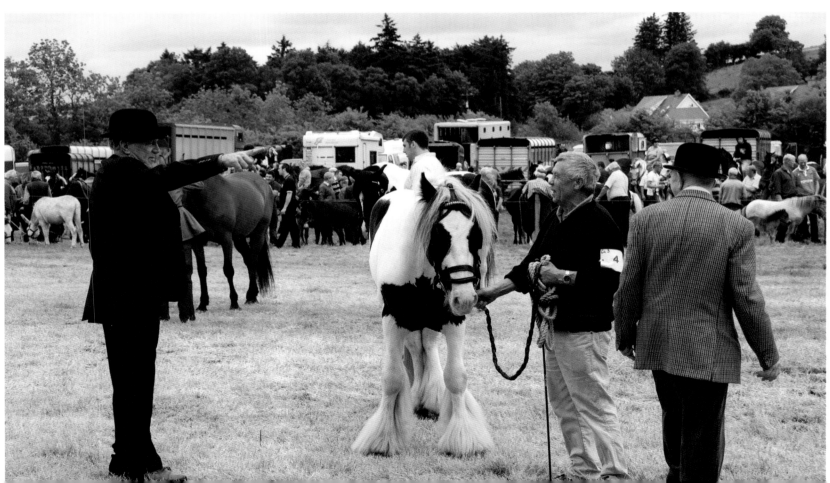

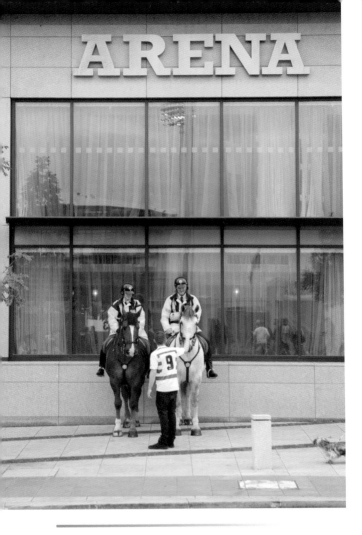

Above: Garda Mounted Unit, Tallaght, Dublin.

Right: Horse Fair, Spancilhill, Ennis, County Clare.

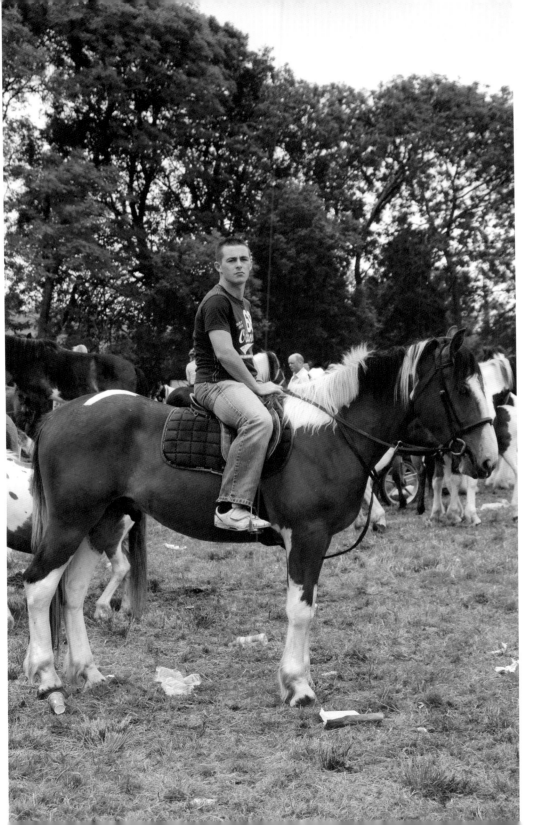

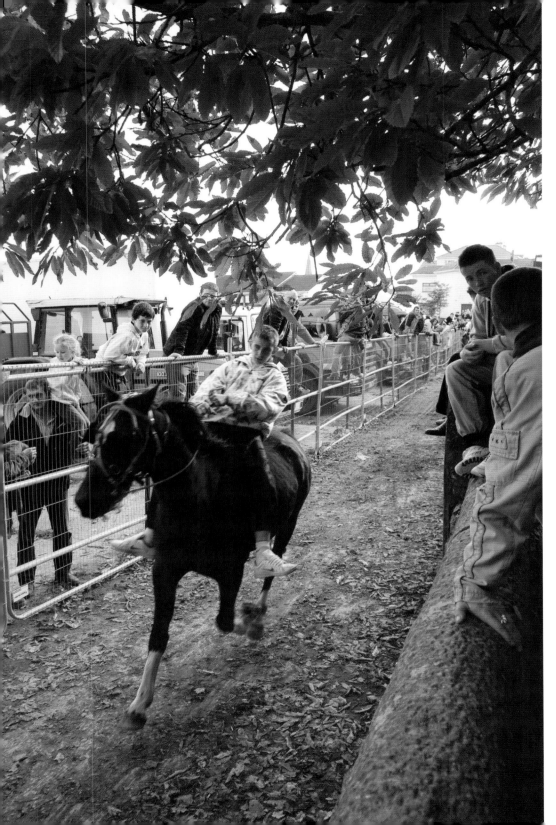

Left: Horse Fair, Ballinasloe, County Galway.

Below: Gap of Dunloe, County Kerry.

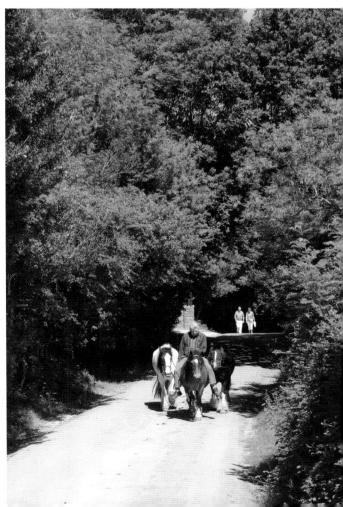

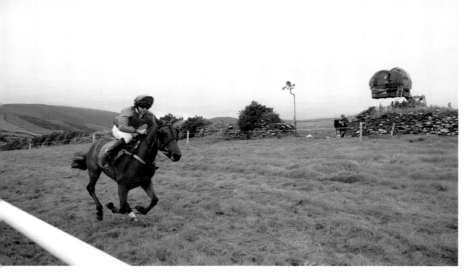

Flapper Races, Dingle, County Kerry.

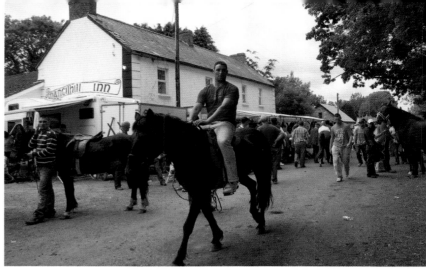

Horse Fair, Spancilhill, Ennis, County Clare.

Below: Christmas Hunt, Knockaderry, County Limerick.

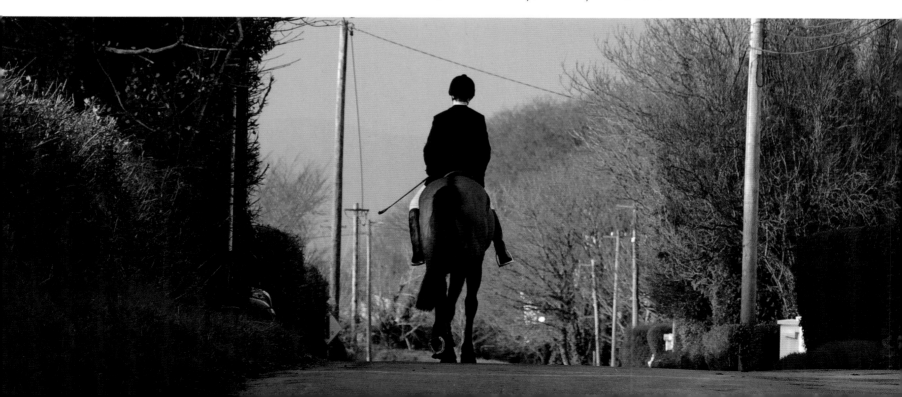

A Day Out

The two biggest annual equine events in Ireland are the Galway Races and the Dublin Horse Show. The Galway Festival is generally held over seven days during the last week in July. The races at the Galway Festival are the most important in Irish horse racing. They feature both flat and jump races over a short and undulating course in Ballybrit, which is on the outskirts of Galway City. Almost a sixth of all the people who attend races in Ireland throughout the year attend Ballybrit over the seven days of racing and the festival is incredibly valuable to the local economy. The numbers are staggering: over 150,000 people attend, with almost one third of these attending on the Thursday for the Galway Hurdle. The admissions alone generate over €3 million for the organisers and almost €19 million is placed in on-course bets.

Whereas the popularity of the Galway Festival is a relatively recent occurrence, the Dublin Horse Show has been in existence for over 150 years and remains a popular outing for many. This five-day event, which attracts many families, is generally held during the week after the August bank holiday. There is a bewildering array of competitions held from early morning through to the evening on each day of the Horse Show.

Every week throughout the year there are events in many locations around the country, ranging from hunts to races and from show jumping to horse fairs. These events vary immensely in scale, from the significant prize money and large attendances at the Irish Derby to the relatively modest amounts on offer at smaller race meetings such as the Dingle races and point to point events. The cross-societal mix is probably at its most visible at big race meetings. The Curragh hosts most of the top Irish flat races and the jewel in the crown is the Irish Derby. The racing is held over three days during June and the festival is a major social event. The people attending go to considerable lengths to dress up for the occasion and quality food and drink is in plentiful supply. The crowds (in the reserved enclosure at least) are entertained by bands both during and after the racing. In contrast, the organisers in Galway provide a fun fair, bookies, tote facilities, picnic tables and the usual array of burger and hot dog vendors in the infield section, and entry is free once parking is paid for.

The country's horse fairs attract a varied crowd to those that attend the larger race meetings. Most of the fairs are held in towns, but there are the occasional ones which are held in more rural aspects, like the fair at Spancilhill, which is held in the countryside about six kilometres from Ennis. This fair is held in the same field annually, a few hundred metres from the Cross of Spancilhill. There is one pub and a handful of houses in the vicinity of the field. Tea and cakes are sold from the garage at the side of one of the nearby bungalows.

In contrast, Ballinasloe is probably the largest horse fair in Ireland and there is a nine-day festival held in the town to coincide with it. The fair green is just off the former main Dublin to Galway road, on the western side of the town. It is held in a large field bounded by a road on the west side, the town on the north and the gently sloping inclines on the east and south sides. The field is like a large amphitheatre and St John's church, which is on the highest point overlooking the green, dominates the view. Outside the church, the slope leading down to the fair green is covered with caravans, horseboxes, vans and cars, and the area teems with activity. In addition, there are organised competitions at both the Ballinasloe and Spancilhill fairs, whereas there are none at the Puck Fair and Smithfield horse markets. Many of these fairs have survived for hundreds of years and continue to be colourful, lively places to visit. Hopefully they will flourish for many more years to come.

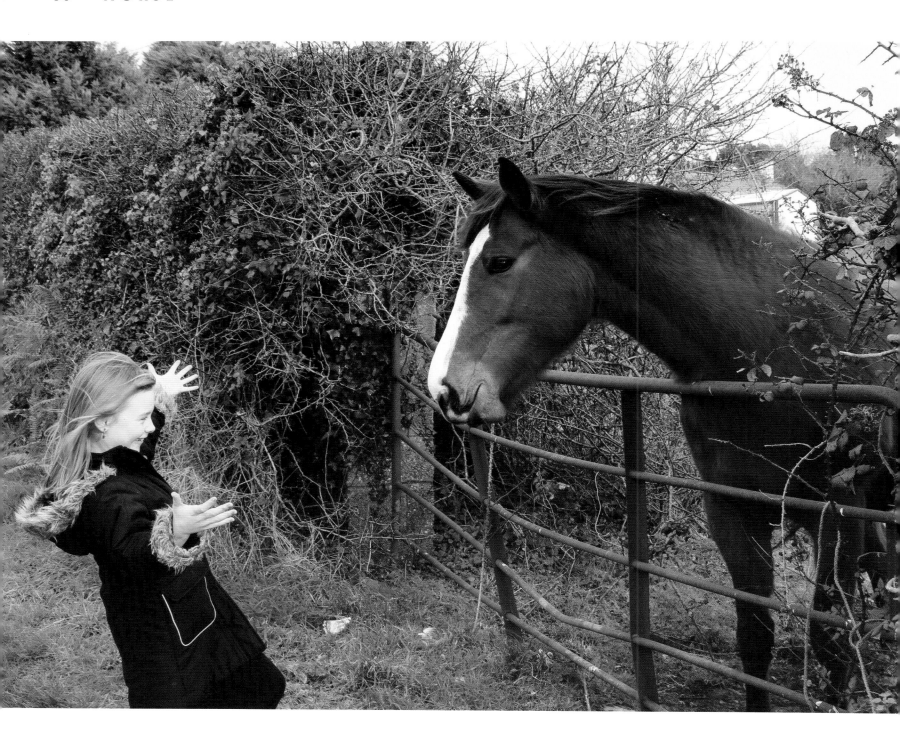

Opposite: Christmas Hunt,
Knockaderry, County Limerick.

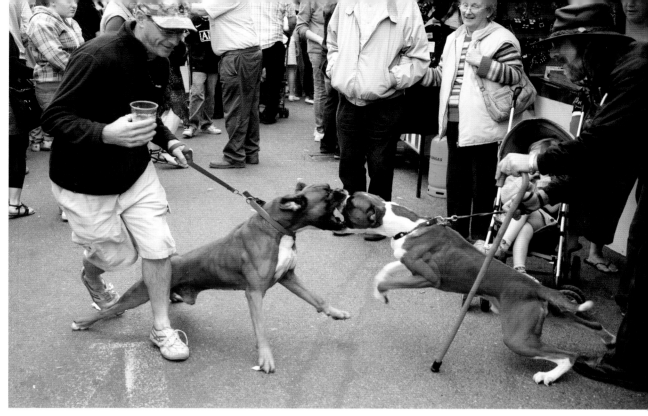

Puck Fair, Killorglin, County
Kerry.

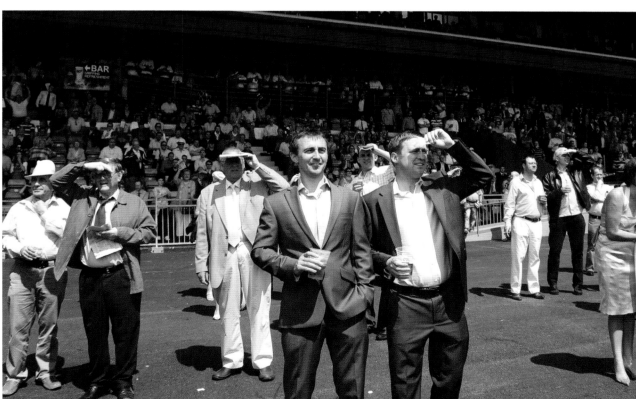

Irish Derby Festival, Curragh,
County Kildare.

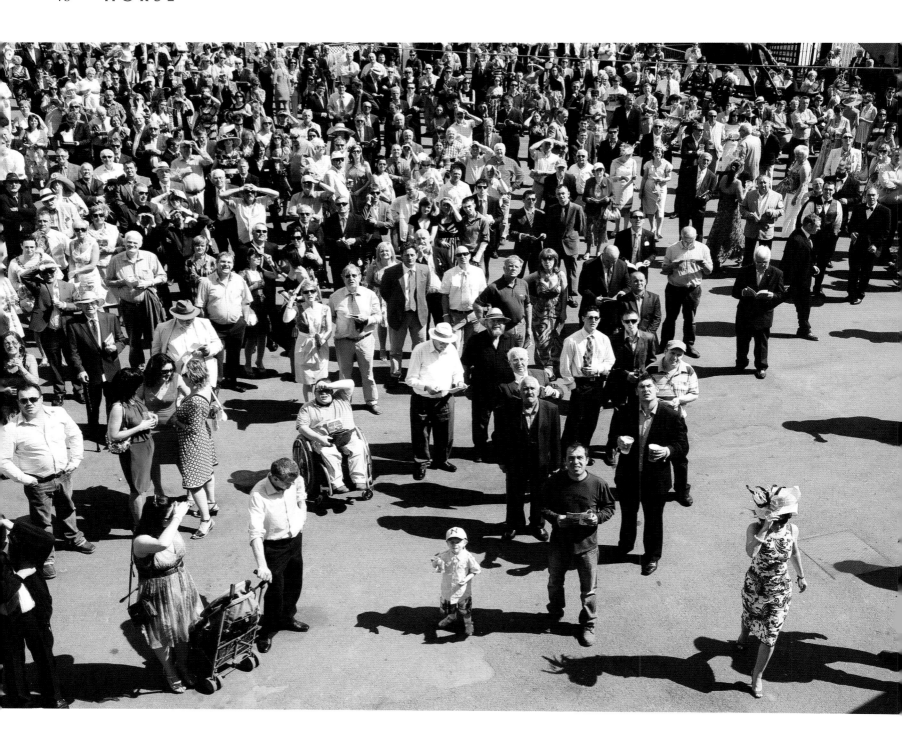

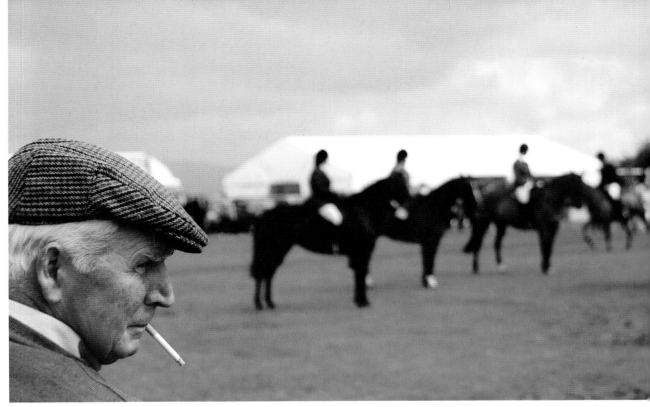

Opposite: Irish Derby Festival,
Curragh, County Kildare.

Ballina Agricultural Show,
County Mayo.

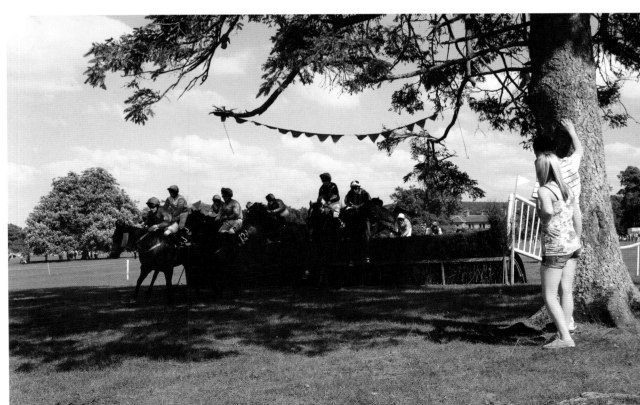

Point to Point, Stradbally Hall,
County Laois.

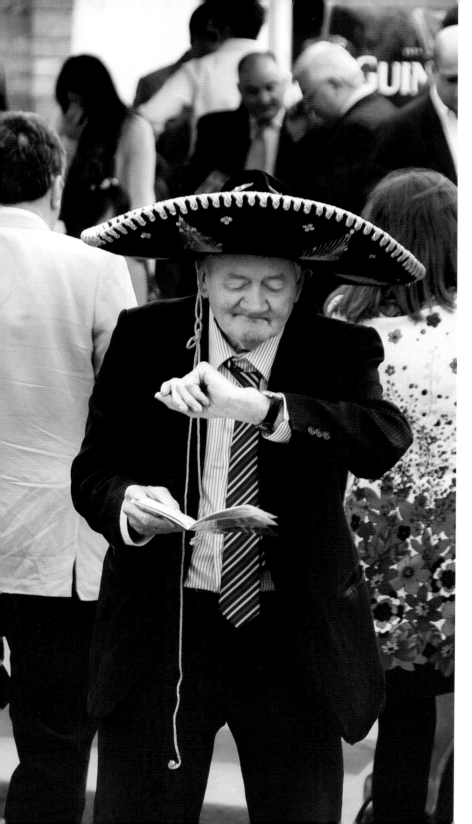
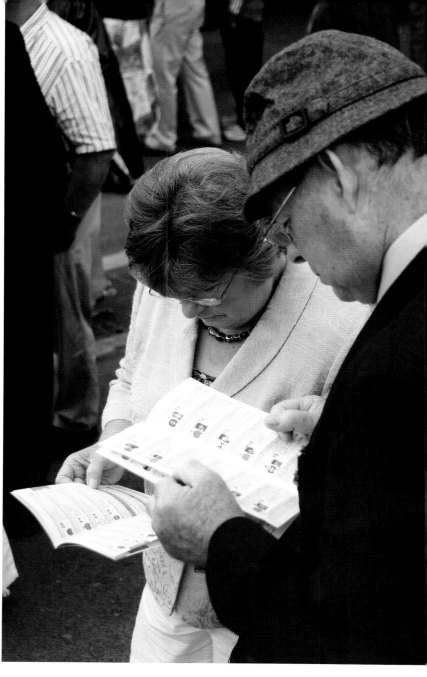

Left and above: Galway Races Summer Festival, County Galway.

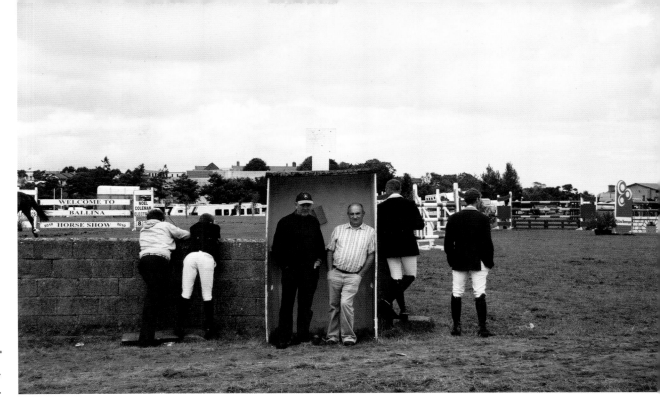

Ballina Agricultural Show,
County Mayo.

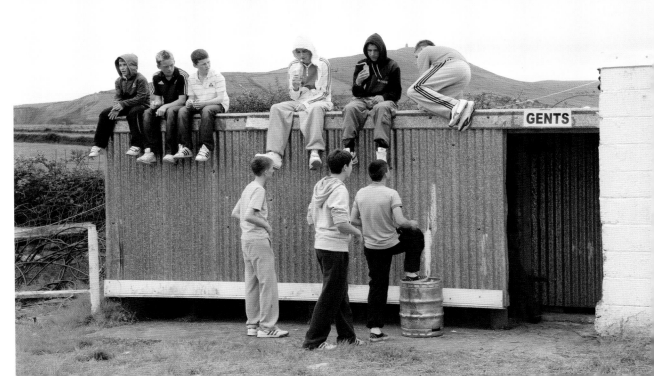

Flapper Races, Dingle, County
Kerry.

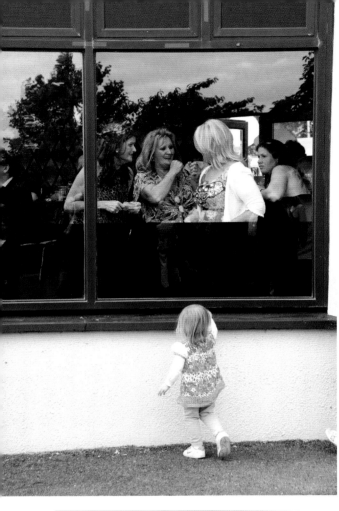

Above: Irish Derby Festival, Curragh,
County Kildare.

Right: Horse Fair, Spancilhill, Ennis,
County Clare.

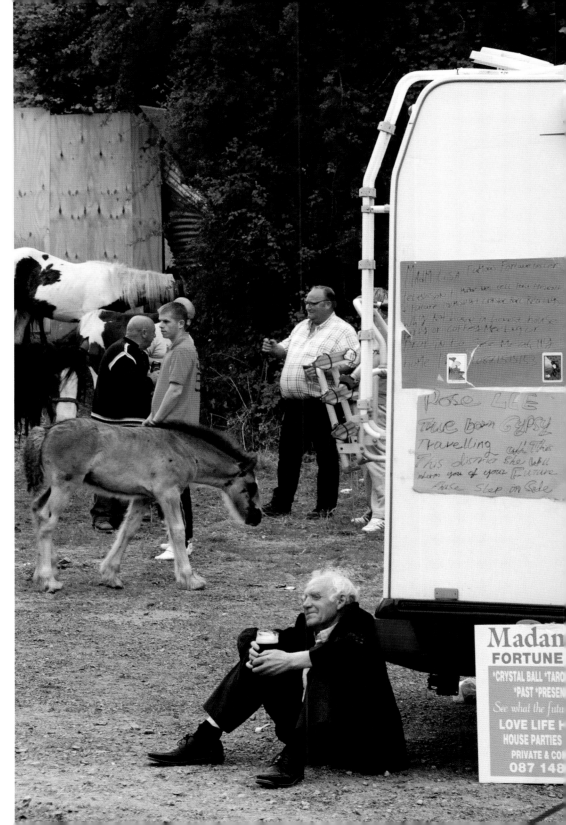

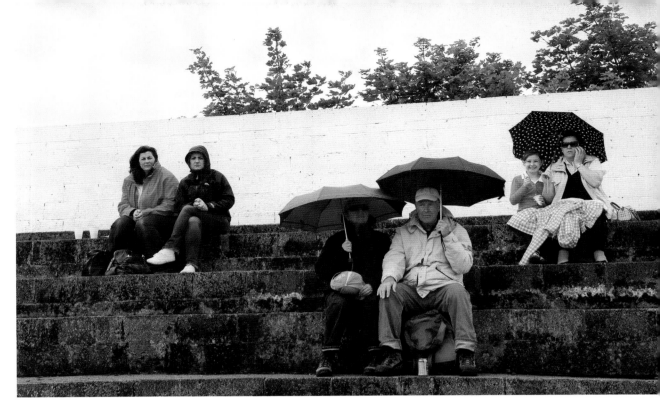

Ballina Agricultural Show,
County Mayo.

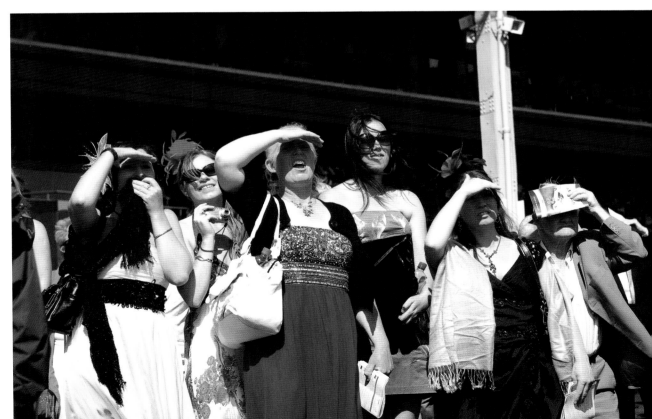

Irish Derby Festival, Curragh,
County Kildare.

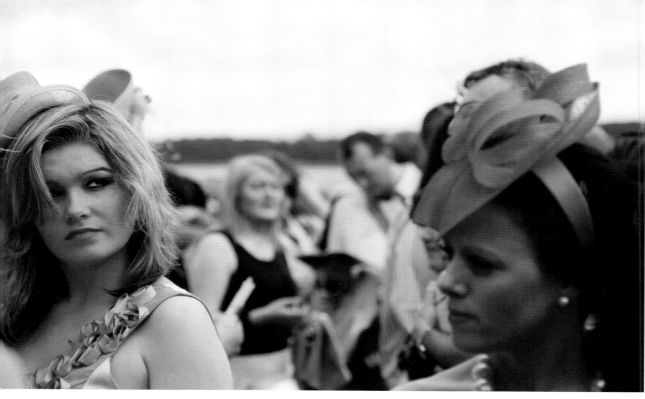

Left and below: Irish Derby Festival, Curragh, County Kildare.

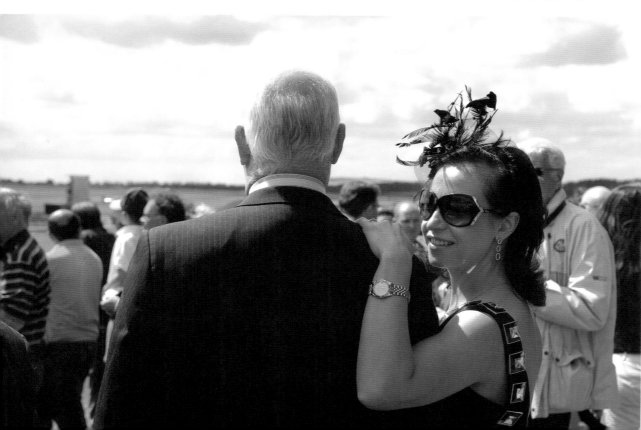

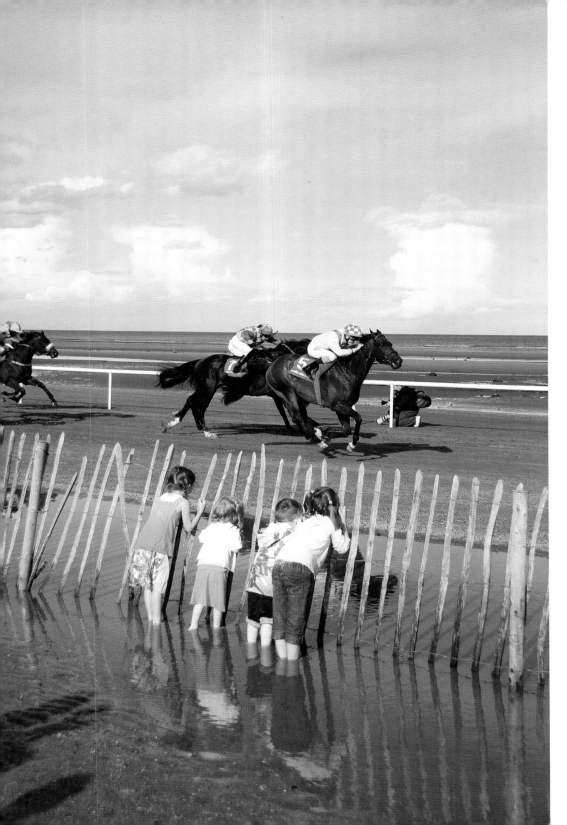

Left: Laytown Races, County Meath.

Below: Horse Market, Smithfield, Dublin.

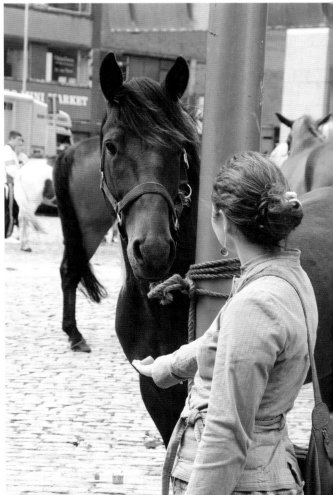

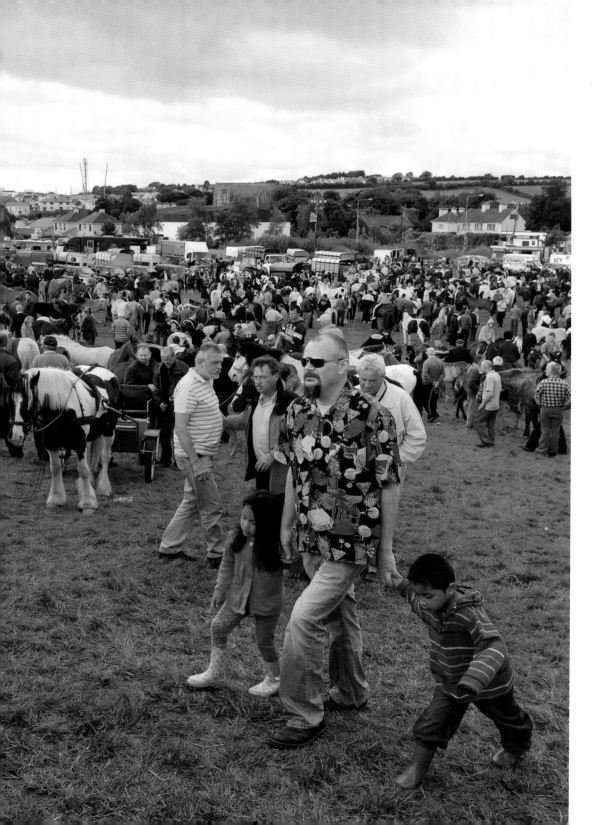

Puck Fair, Killorglin, County Kerry.

Opposite: Irish Derby Festival, Curragh,
County Kildare.

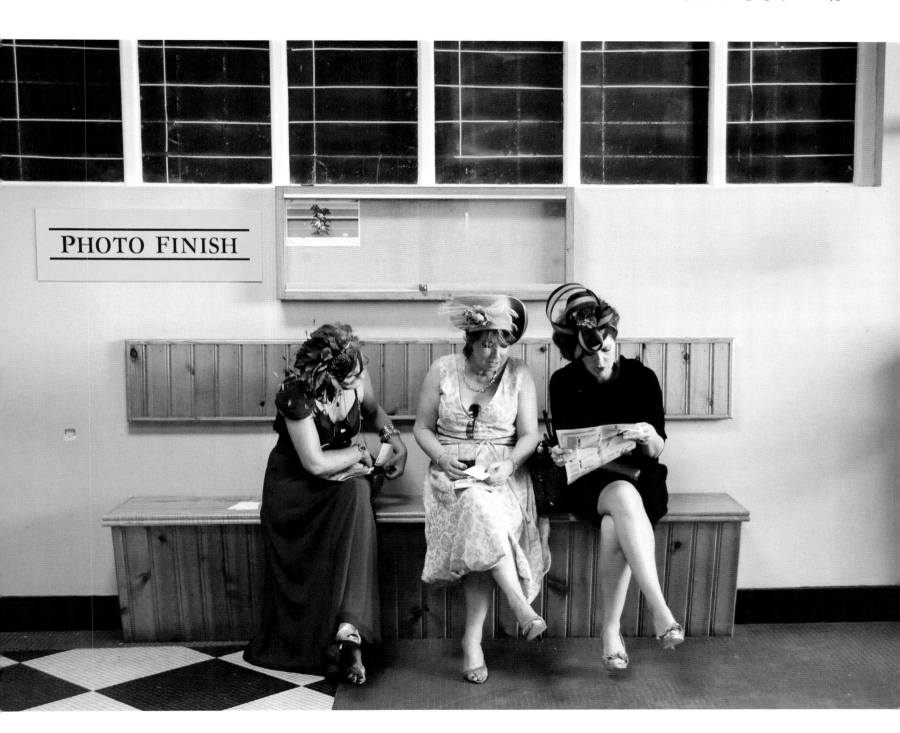

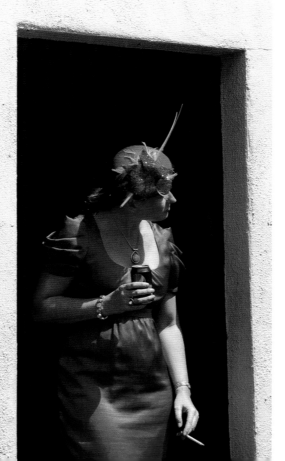

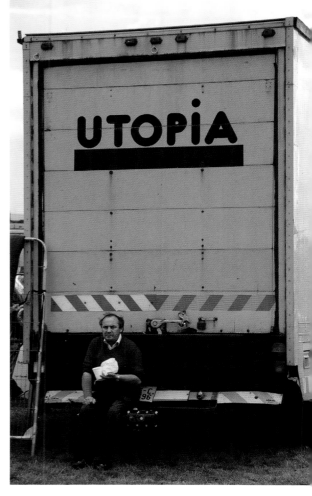

Above: Puck Fair, Killorglin, County Kerry.

Left: Irish Derby Festival, Curragh, County Kildare.

Irish Derby Festival, Curragh, County Kildare.

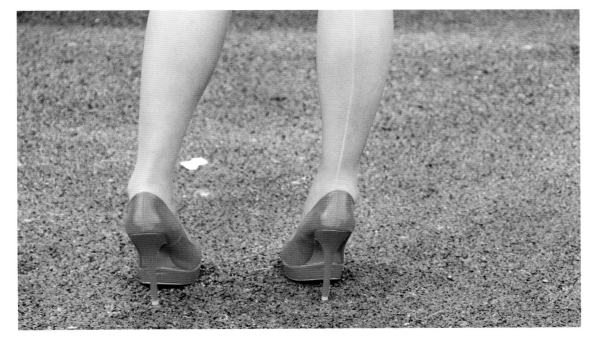

Galway Races Summer Festival, County Galway.

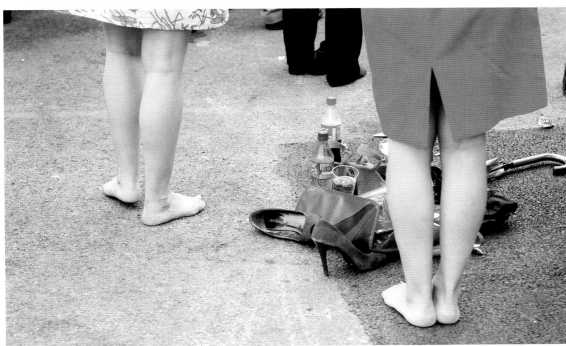

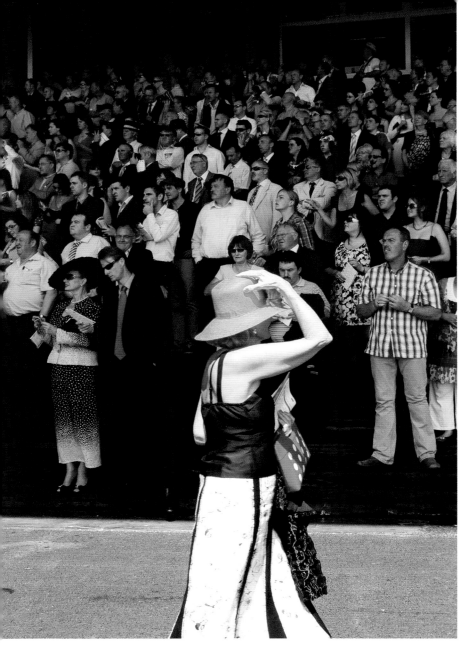
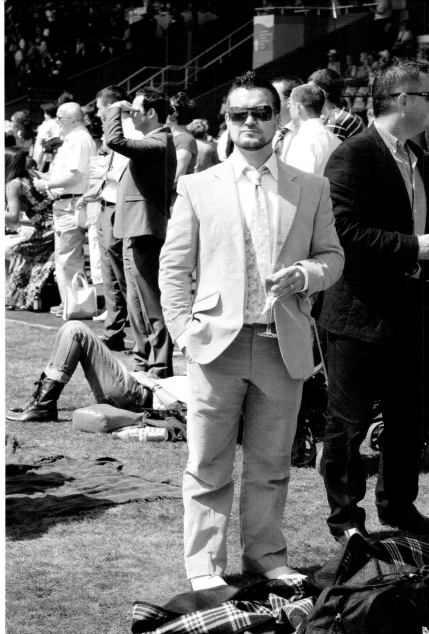

Irish Derby Festival, Curragh, County Kildare.

Galway Races Summer Festival,
County Galway.

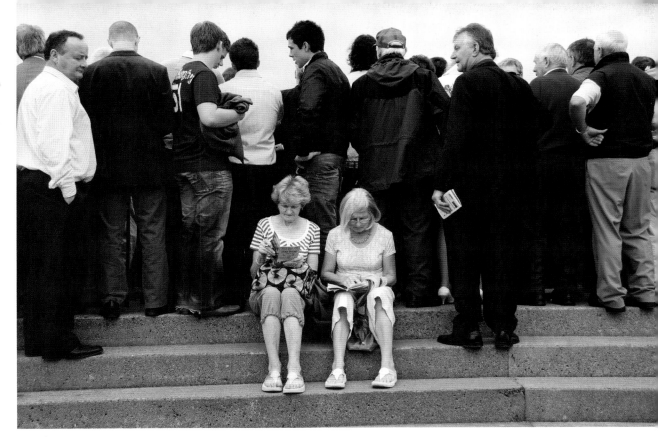

Dublin Horse Show, RDS,
Dublin.

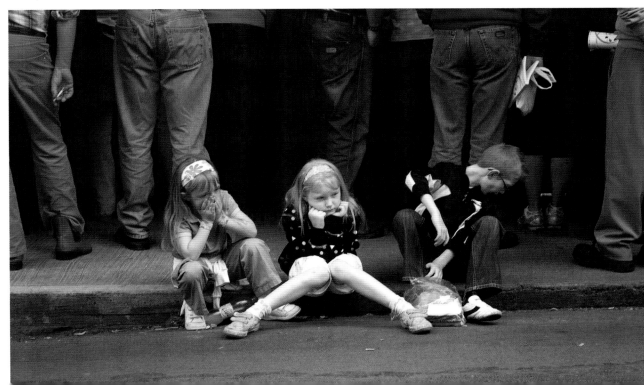

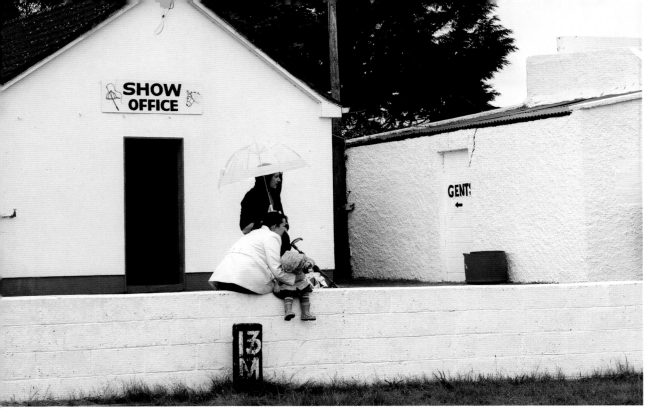

Ballina Agricultural Show,
County Mayo.

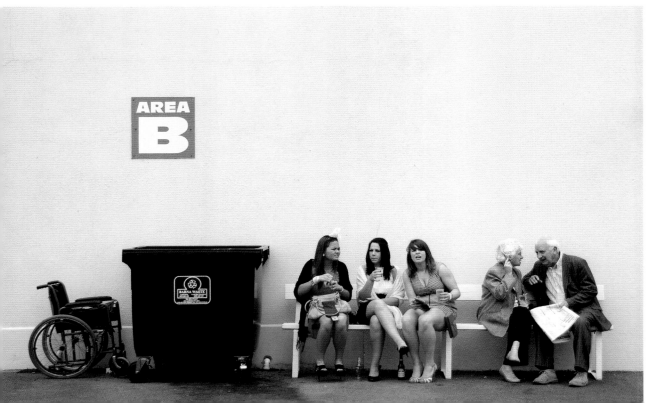

Galway Races Summer Festival,
County Galway.

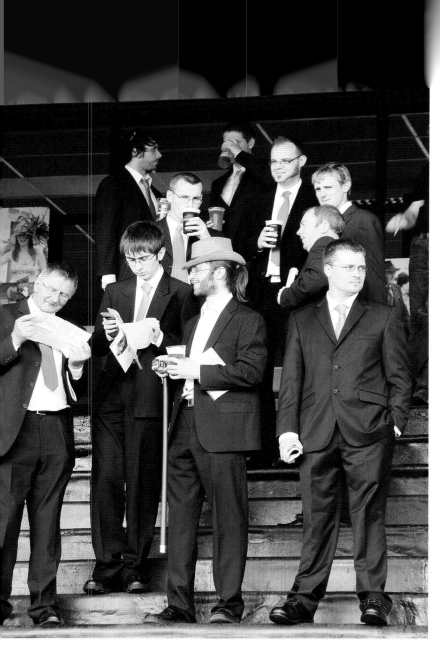
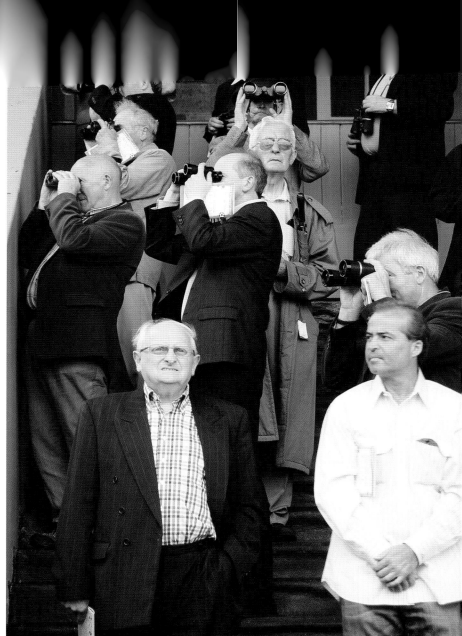

Irish Derby Festival, Curragh, County Kildare.

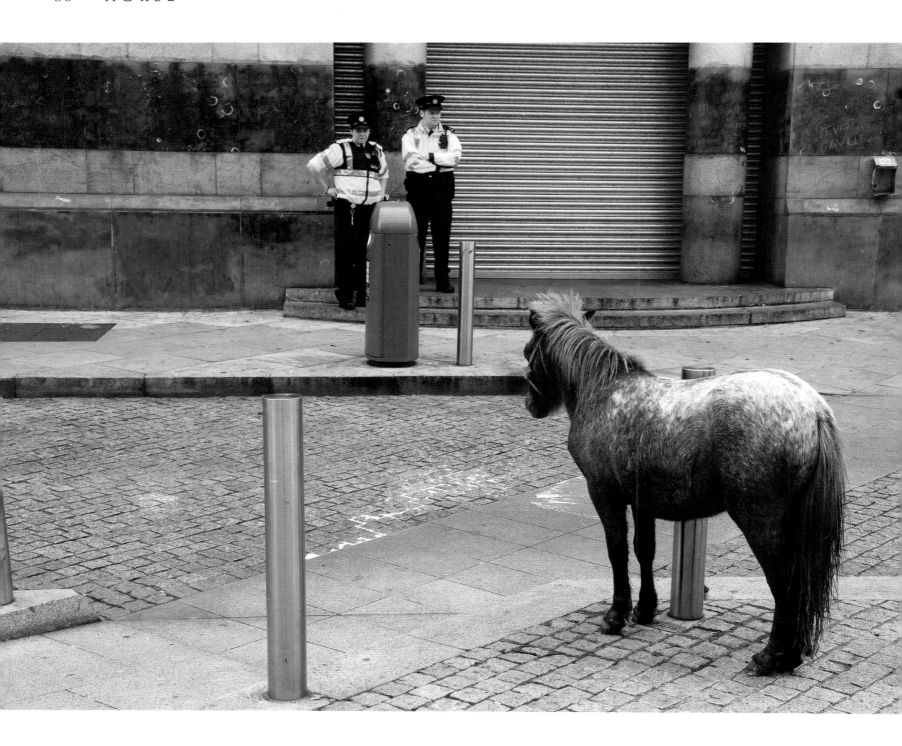

Opposite: Horse Market,
Smithfield, Dublin.

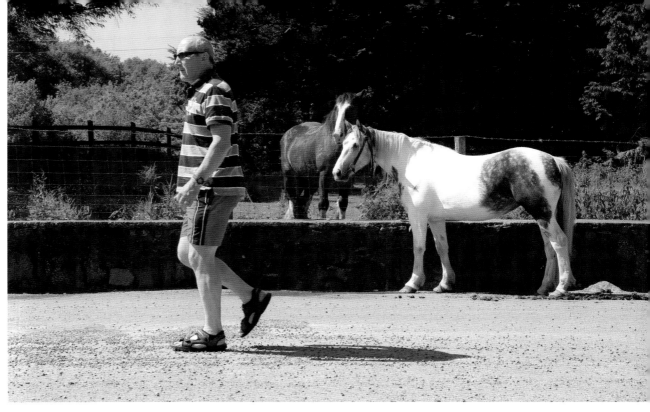

Gap of Dunloe, County Kerry.

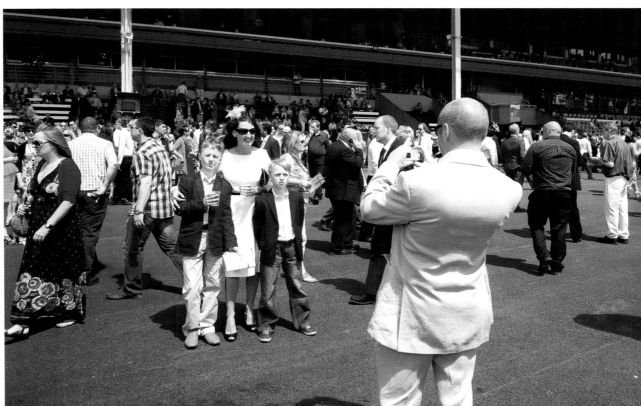

Irish Derby Festival, Curragh,
County Kildare.

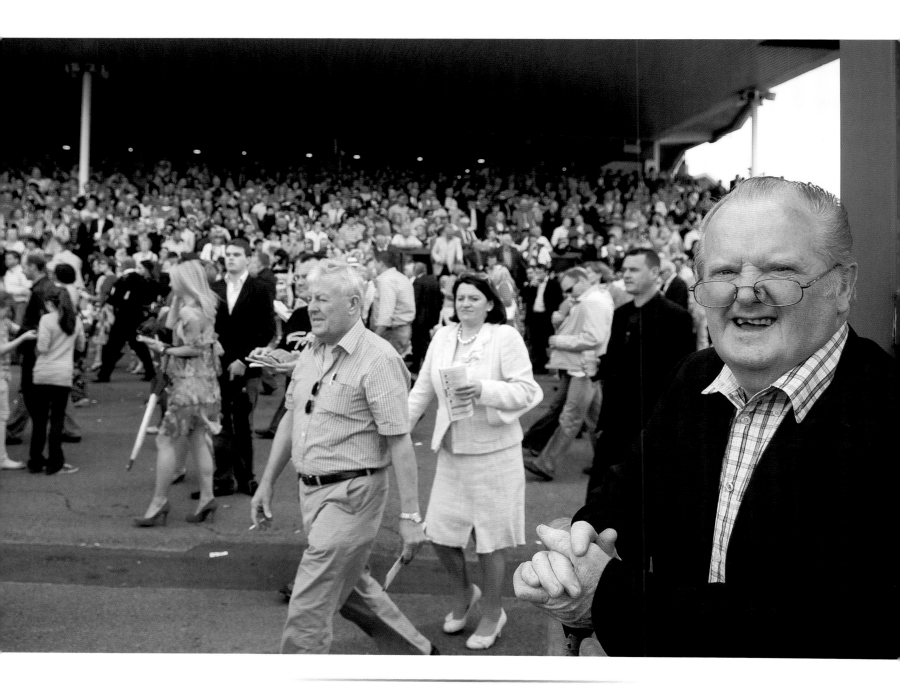

Galway Races Summer Festival, County Galway.

Wheeling and Dealing

It is no surprise that betting is a significant feature of the horse racing industry. Over one third of the people working in racing are employed in this activity. At major race meetings, people are never more than a few metres from a bookie or a tote office ready to relieve punters of hard-earned cash. On average, each of the 150,000 people who attended the Galway Races in 2010 placed €125 in bets (on one of the days of the festival the average amount wagered per person attending was nearer to €170). In Galway there were three rings of bookmakers and rows upon rows of open tote windows. At the Irish Derby Festival, the number of bookmakers in the betting ring grew steadily over the weekend and there were probably over fifty touting for business by Sunday. There were also numerous tote points around the Grandstand and there were even some in the bars. The betting rings at the point to point meeting in Stradbally and the Dingle races were smaller but were equally busy. In both places, the bookmakers also provided television coverage of other, larger race meetings. It is difficult to know if horse racing exists to service the betting industry or if the betting industry exists to service horse racing. In truth it is probably a bit of both.

The horse fairs are vivacious places and everyone seems to know everyone else. Recently, sales have been slow, as there were few buyers willing to offer reasonable prices for horses. As well as the horse traders, these events attract a range of vendors selling items such as horse blankets, saddles, and bridles. There was a shop at the Curragh Racecourse selling ladies' hats and a stand at Puck Fair promoting devotion to St Philomena. At the Dublin Horse Show, which has a huge trade section, it was possible to dress yourself, equip your horse, furnish your house and make over your garden. It was a kind of equine one-stop shop.

At the larger race meetings, alcoholic beverages are readily available and are a significant feature of the day out. Surprisingly, the point to point racing at Stradbally Hall did not have a bar (although on a blisteringly hot day the whipped-ice-cream van did a roaring business). Drink was not a large feature at the horse fairs or smaller races either. However, the tiny bar at the Dingle races did run dry towards the end of the third day. At the Curragh Racecourse, there was a choice between indoor bars, a champagne bar, a couple of outdoor bars and a number of roving vendors. The bars in Galway ran the full length of the Grandstand. For some attending the races, the day consisted of going to the bar to order a drink, moving a few steps to one side to place a bet, and then glancing out the window to see the end of the race. A smaller number didn't even bother to watch the racing because other sporting events such as soccer, Gaelic football and hurling were being shown on big screens in the bars. In some ways it appeared that the racing was almost incidental to the other action around the track.

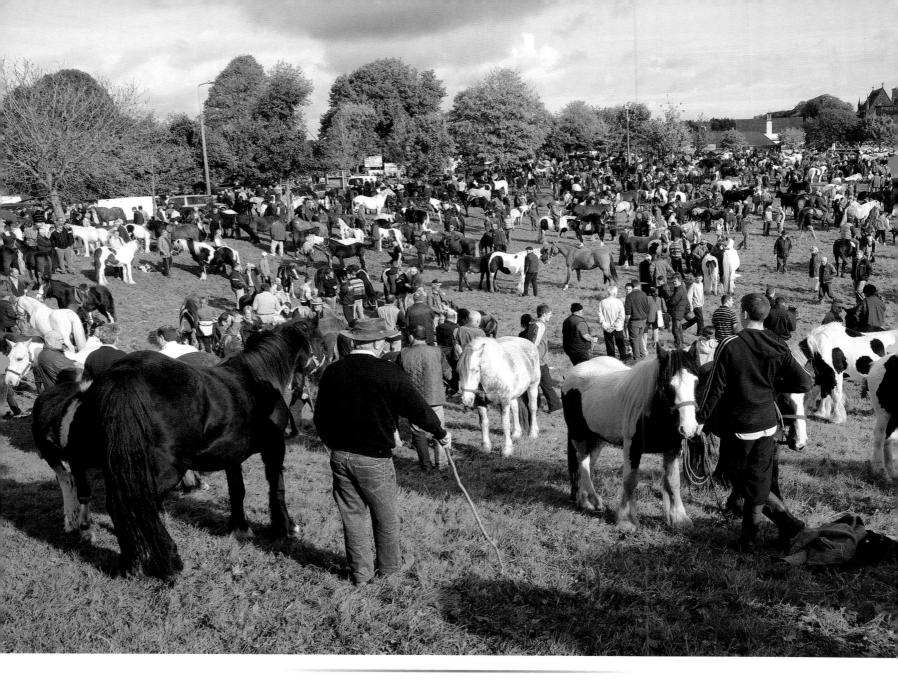

Horse Fair, Ballinasloe, County Galway.

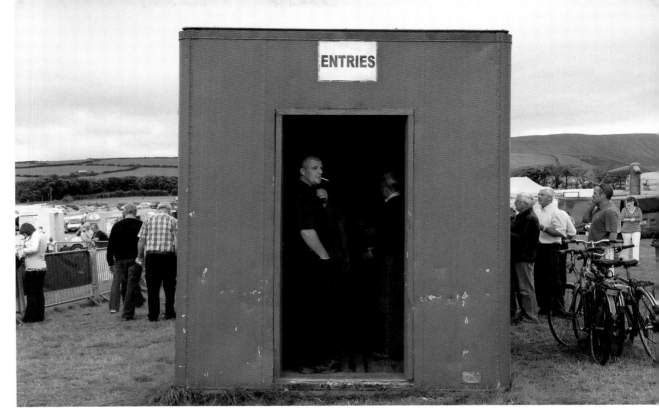

Flapper Races, Dingle, County Kerry.

Dublin Horse Show, RDS, Dublin.

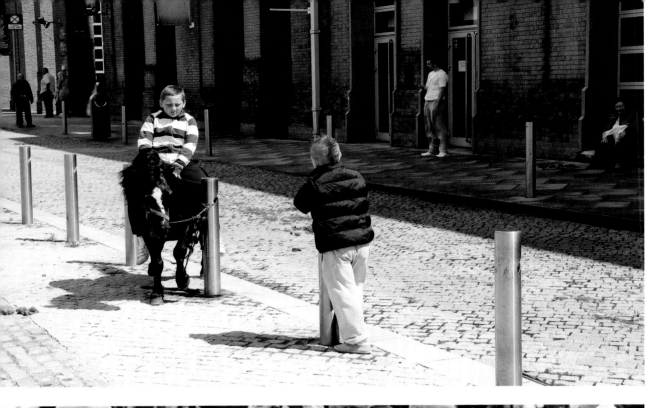

Horse Market, Smithfield, Dublin.

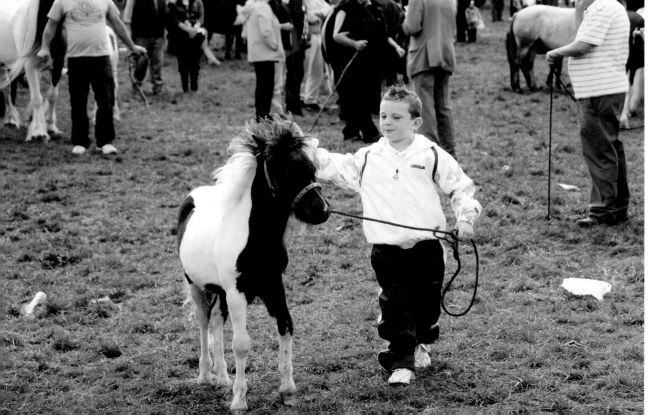

Puck Fair, Killorglin, County Kerry.

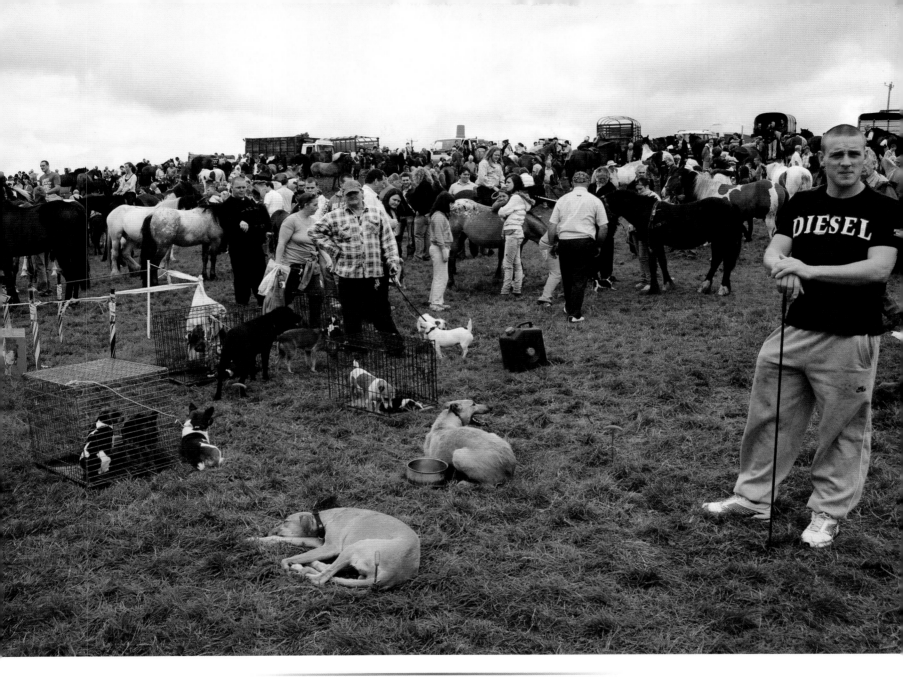

Puck Fair, Killorglin, County Kerry.

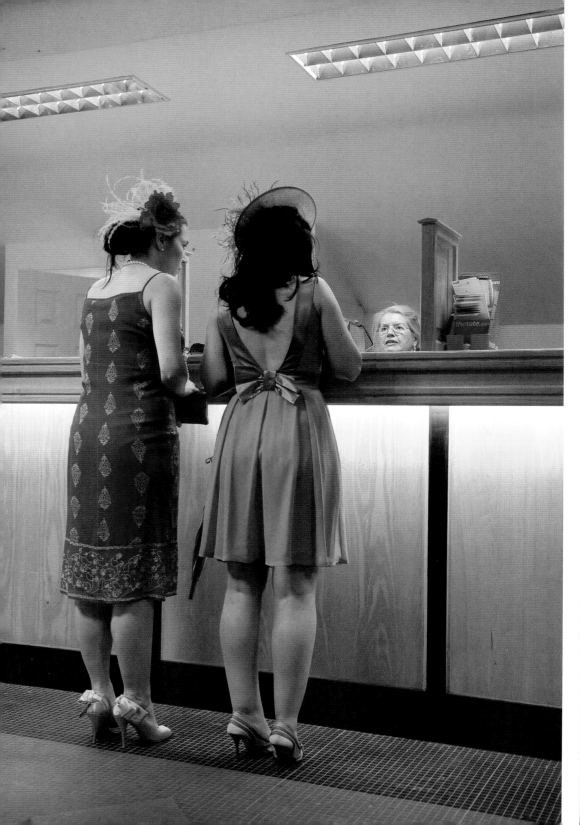

Left: Irish Derby Festival, Curragh, County Kildare.

Below: Puck Fair, Killorglin, County Kerry.

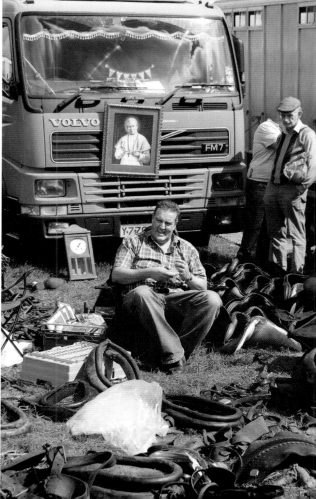

Horse Market, Smithfield, Dublin.

Irish Derby Festival, Curragh, County Kildare.

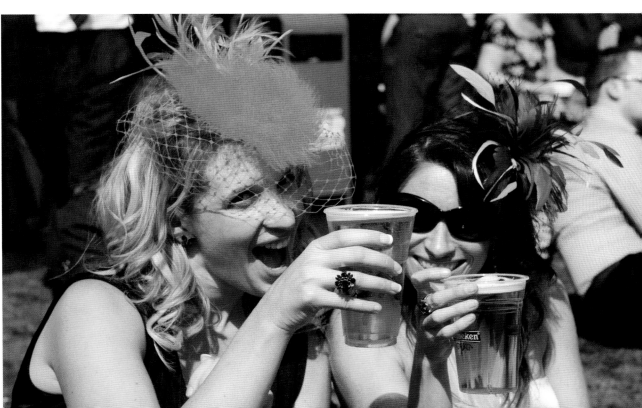

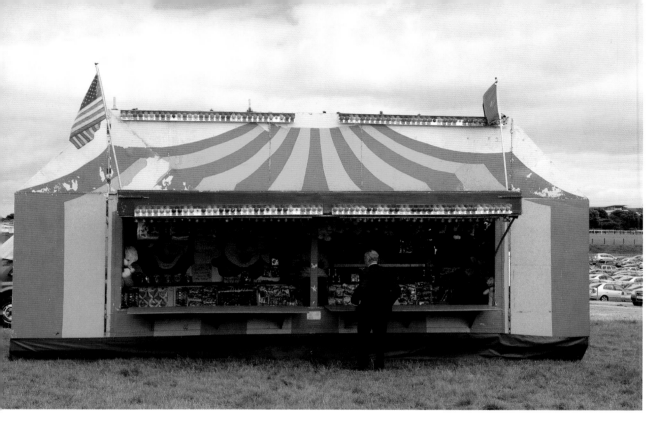

Galway Races Summer Festival, County Galway.

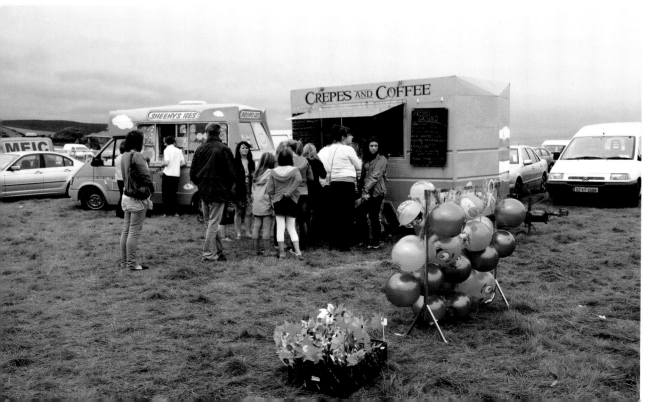

Flapper Races, Dingle, County Kerry.

Irish Derby Festival, Curragh,
County Kildare.

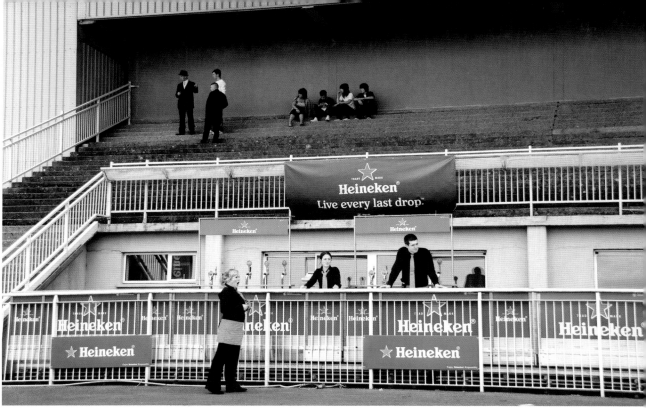

Flapper Races, Dingle, County
Kerry.

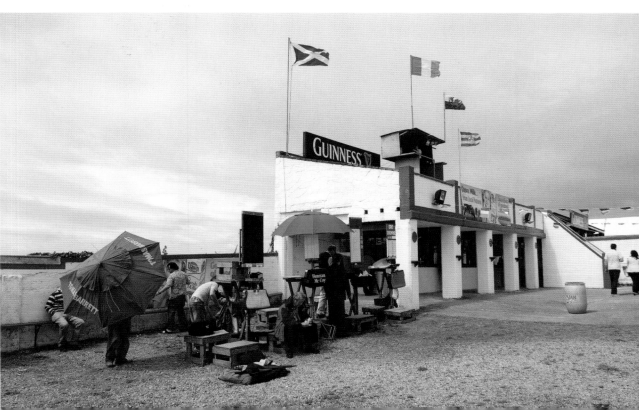

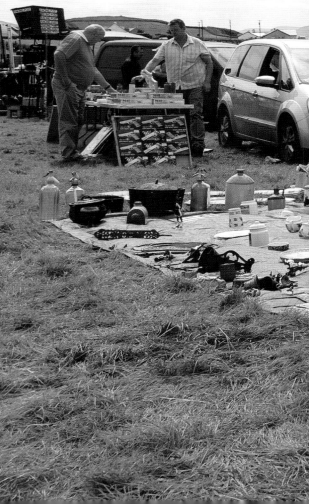

Left: Puck Fair, Killorglin, County Kerry.

Flapper Races, Dingle, County Kerry.

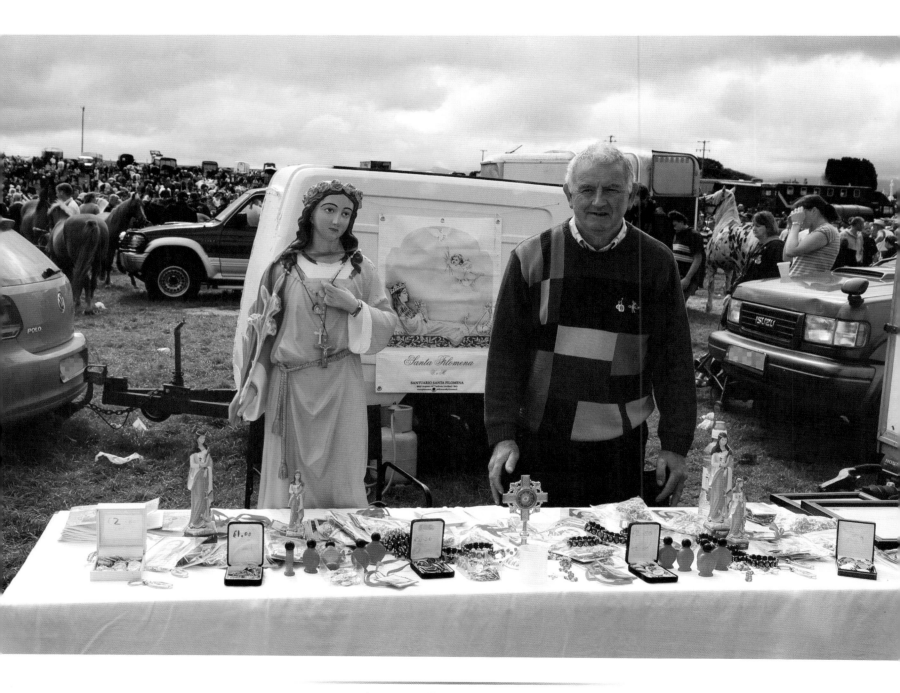

Puck Fair, Killorglin, County Kerry.

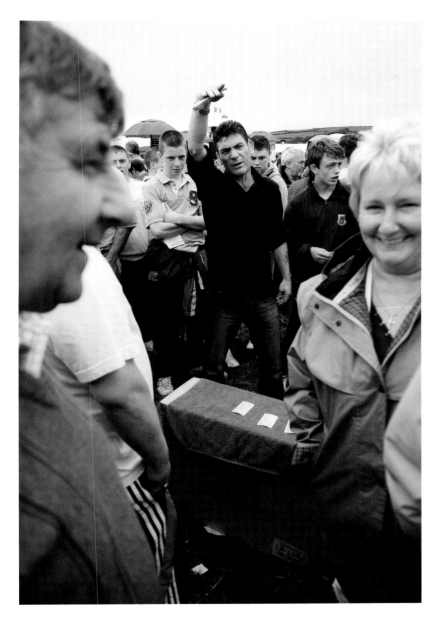

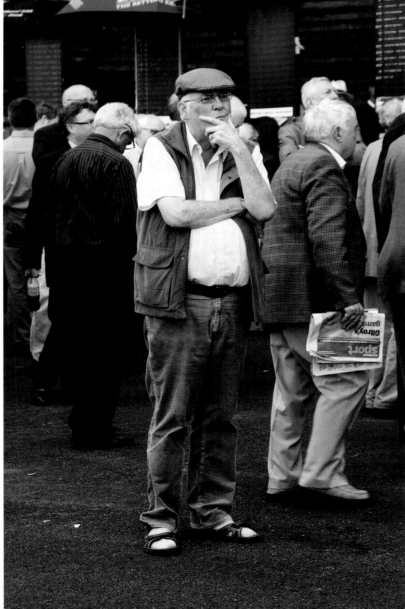

Left: Flapper Races, Dingle, County Kerry.

Right: Irish Derby Festival, Curragh, County Kildare.

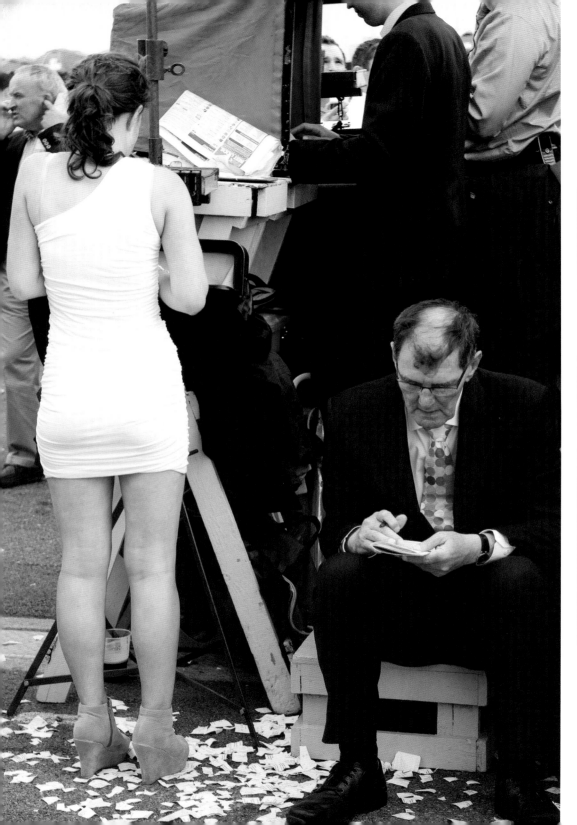

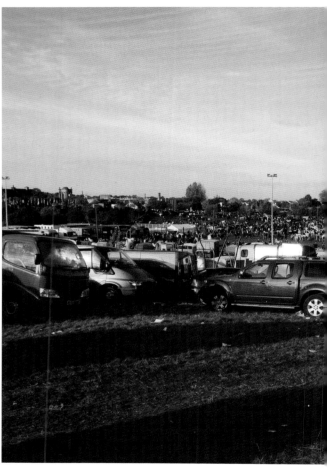

Left: Galway Races Summer Festival, County Galway.

Above: Horse Fair, Ballinasloe, County Galway.

Right: Irish Derby Festival, Curragh,
County Kildare.

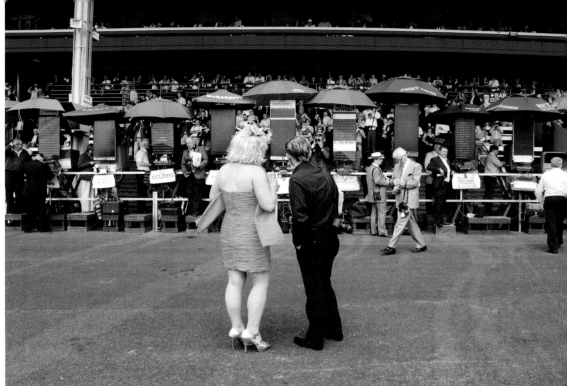

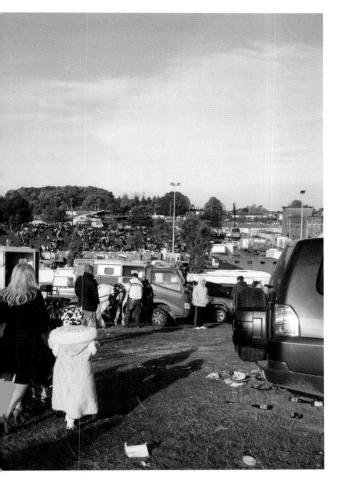

Right: Horse Fair, Ballinasloe, County
Galway.

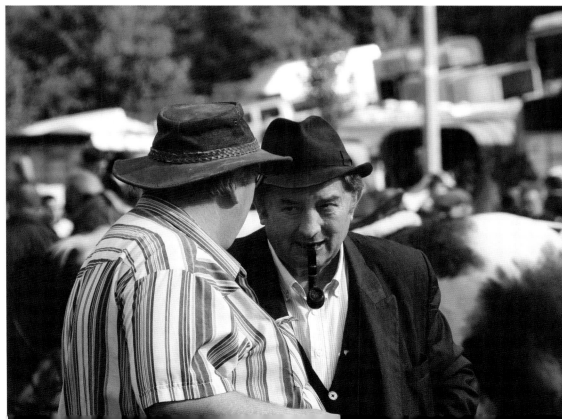

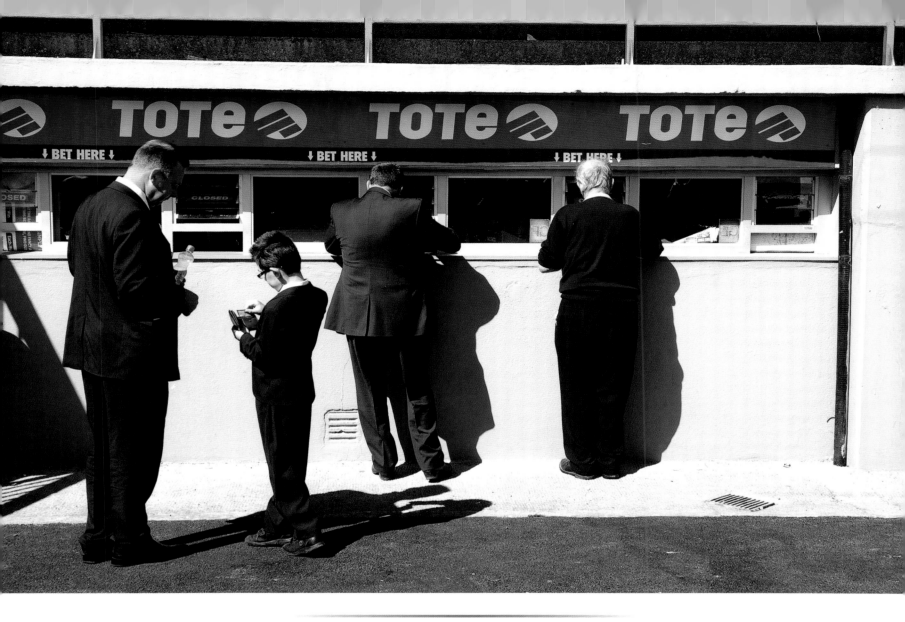

Irish Derby Festival, Curragh, County Kildare.

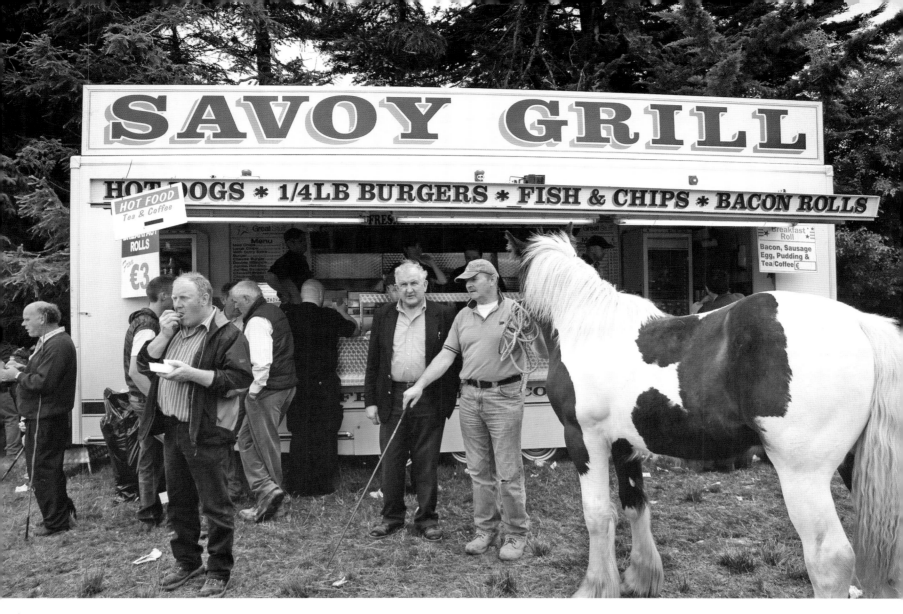

Horse Fair, Spancilhill, Ennis, County Clare.

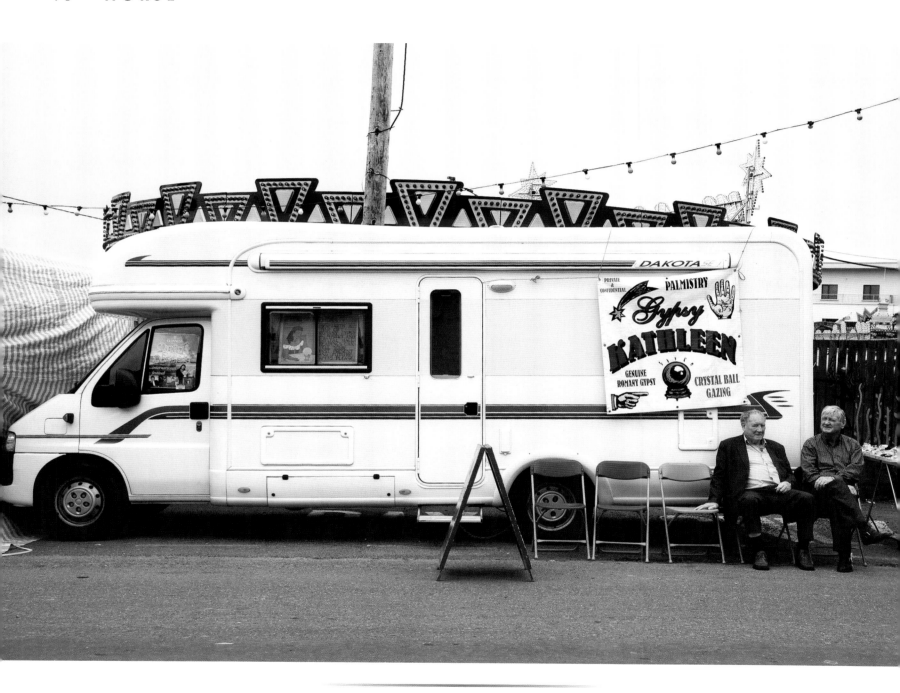

Puck Fair, Killorglin, County Kerry.

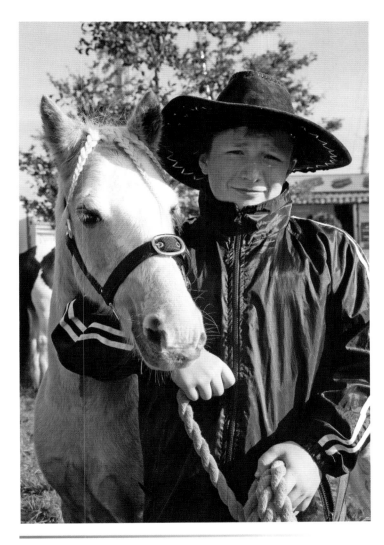

Above: Horse Fair, Ballinasloe, County Galway.

Right: Horse Fair, Spancilhill, Ennis, County Clare.

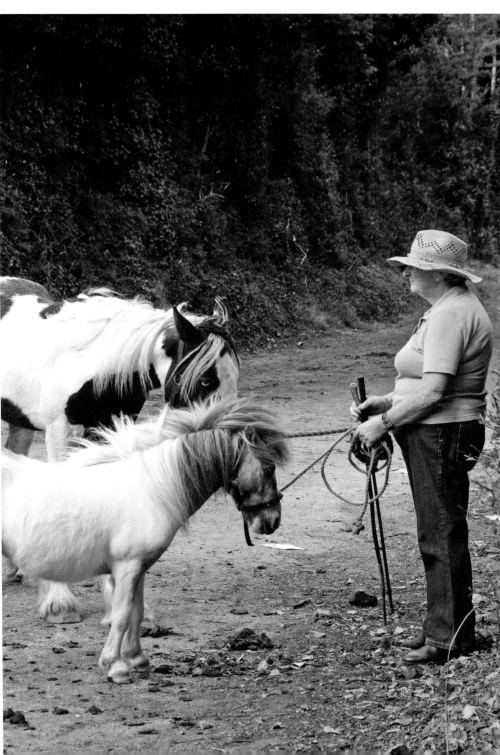

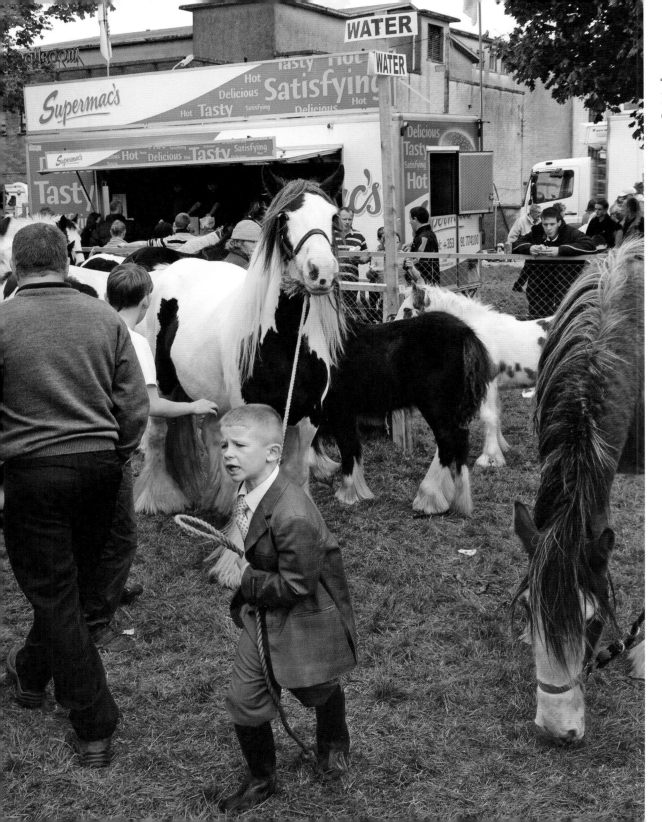

Horse Fair, Ballinasloe, County Galway.

Opposite: Horse Fair, Spancilhill, Ennis, County Clare.

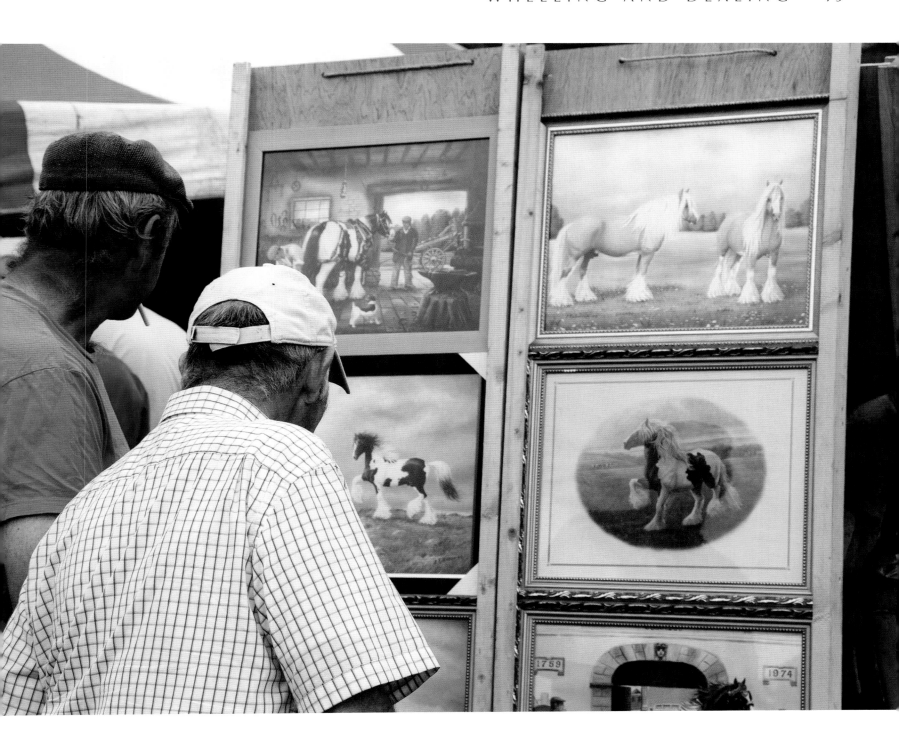

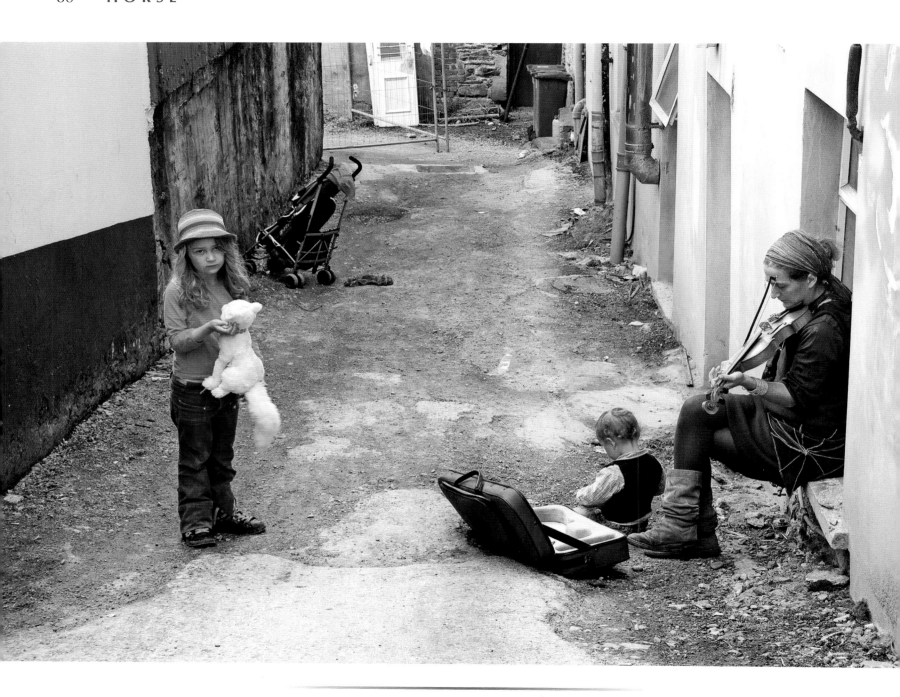

Puck Fair, Killorglin, County Kerry.

The Working Horse

Photographer Bill Doyle chronicled life in Dublin over half a century, as the city transformed itself into the modern vibrant place it is today. His work is both gentle and insightful and the subjects of his photographs are always portrayed sympathetically. He captured many images of horses working in the streets of Dublin, from horses pulling wagons for dairies and scrap merchants to some of the last working horses in the Jameson Distillery in Smithfield. His images (amongst many other aspects of Dublin life) captured the final stages of the move away from the horse towards the more mechanical forms of transportation. However, one photograph in particular stands out. It is of three children transporting a wrecked Morris Minor car on the back of a horse-drawn wagon through one of Dublin's Georgian streets. It epitomises a kind of a last stand or an act of defiance on the part of the working horse in the war against mechanisation, a war that it cannot win.

While the concept of the working horse has diminished almost to the point of extinction, there are still some examples where horses are used in the course of the working day, well away from the glamour of the race track or the main jumping ring in the Dublin Horse Show. C.W. Anderson, the renowned American horse artist and author, said that 'Many people have sighed for the "good old days" and regretted the "passing of the horse", but today, when only those who like horses own them, it is a far better time for horses.' He is correct in the observation that only those who like horses will take the time and effort to care for one, and the corollary of this is that only those people who like horses will also try to earn some or all of their living from them.

Some working horses, such as those in the Garda Mounted Unit, have a real and substantive role. These horses are highly effective in crowd control and are deployed at many events throughout Ireland. The horses are trained to cope with, and operate under, difficult and occasionally hostile circumstances.

It is hard to foresee circuses travelling with animals for much longer. The National Photographic Archive in Temple Bar has a remarkable photograph of Chipperfield's Circus arriving in Clonmel in 1957. The circus arrived by train and this image shows twelve of their elephants being led from the station to the site of the big top. Back then – and this was less than a generation ago – the arrival of the circus in a town was big news and must-see entertainment. Today, circuses are really only regarded as a day out for the children. With the costs of keeping a touring circus on the road continually increasing, and with more and more active animal rights campaigns, it is certain that there will never be twelve elephants travelling with a circus in Ireland again. Many circuses now travel without animals and the horse will probably be the last of the touring circus animals.

Horses will continue to fulfil ceremonial roles, from weddings to state occasions, and they will always have a niche role in tourism. It is difficult to foresee a time when there would be no horse-drawn jaunting cars making their way through the Gap of Dunloe in Kerry. From police work to circus work to pulling jaunting cars, these horses continue to toil. For the people working with them this is a labour of love and it is clear that there is a real and virtually unbreakable bond between them.

Police Horses

The Garda Mounted Unit is based in the grounds of Áras an Uachtarin in Dublin's Phoenix Park, where they have dedicated stables and training facilities. The Unit was established in the late 1990s and a common misconception is that it performs a mainly ceremonial and public relations function. While there is no doubt that they are a highly visible (and often photographed) part of the force, they are also highly trained in crowd control and are generally deployed at any event where there is either a large crowd attending or where there are indications that there may be trouble. Even though the unit is based in Dublin, they are deployed at events all over the country.

Recruits are only taken into the Mounted Unit every three years or so, and any Garda interested in joining must have at least three years' service on the force before being eligible to apply. It is, however, even harder for horses to get into the unit. Fewer than one in twenty of the horses offered to the Mounted Unit will pass the six-week trial designed to see if they are suitable from a personality and fitness perspective. It is difficult to appreciate the size of a Garda horse until it is seen at close quarters. The Irish draft horse is the horse of choice because of their temperament and build. The training the horses undertake is intense and varied, because it is vitally important that the horses can be relied upon when deployed on duty.

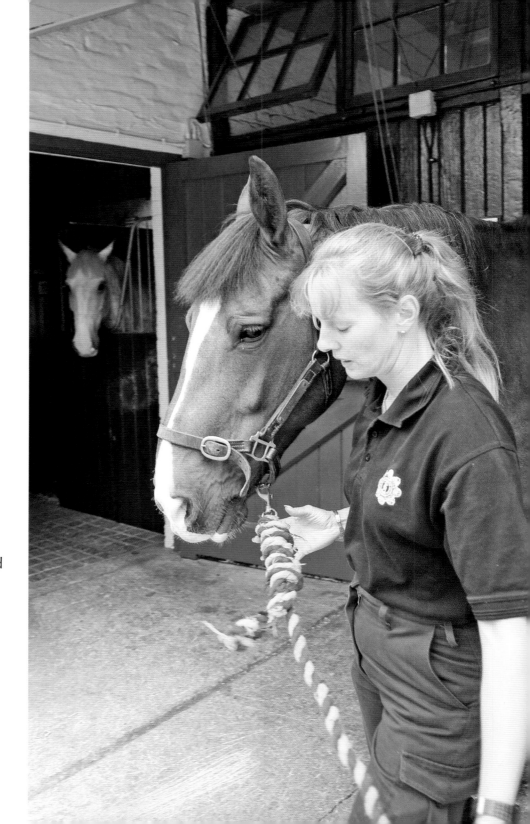

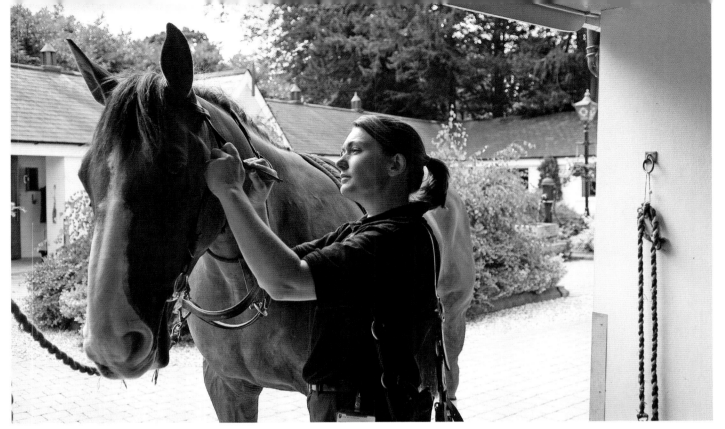

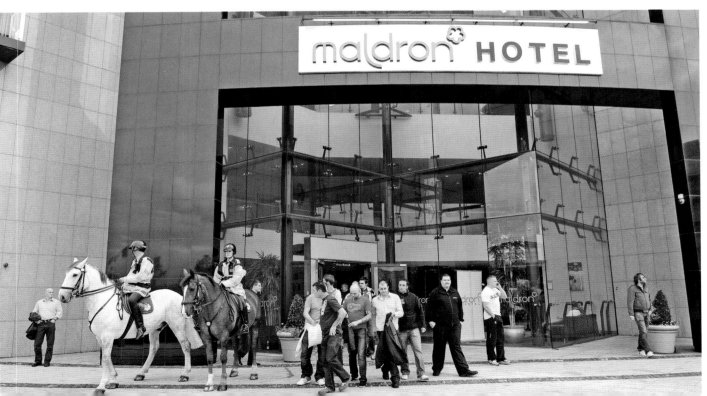

Circus Horses

Mickey Gerbola is the eighth generation of his family in the circus business. He and his wife Tara run Circus Gerbola, and even though their circus is probably one of the smaller ones on the road, the logistics of the operation seem huge. They employ twenty-five people, fourteen of whom perform. They travel with eight to ten trucks, numerous cars, caravans, generators, horseboxes and lifting equipment, all of which has to be moved from site to site on an almost weekly basis. It is a hard life, as the circus is on the road from February to November and it is difficult to operate at a profit. In recessionary times, when people have to tighten their belts, a trip to the circus is one of the first things to be cut. Life for the circus management is a daily struggle, as they try to secure sites, generate publicity and pay wages, as well as putting on shows a couple of times a day, sometimes to a half empty big top.

Everybody in the troupe has numerous jobs to do. As well as being a kind of operations manager for the circus, Mickey is also a clown, the master of ceremonies and he performs with the horses during the show. Tara is the tour manager and a performer, and she also sells popcorn and hotdogs during breaks in the show.

The Gerbolas travel with five much-loved ponies. The two Shetland ponies, Billy and Cody, carry children around the circus ring during intervals in the show. The Gerbolas also travel with three white ponies that perform a short, elegantly choreographed routine during the show.

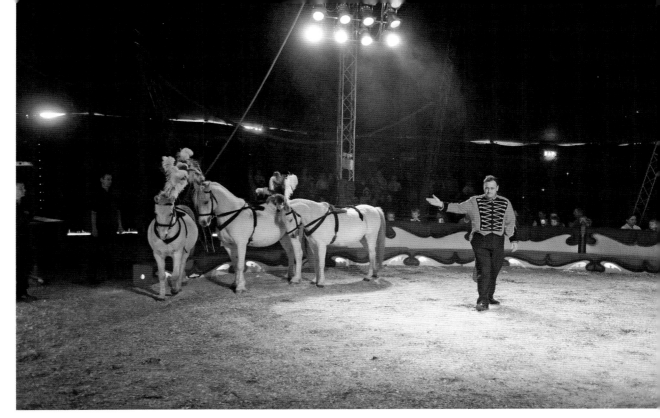

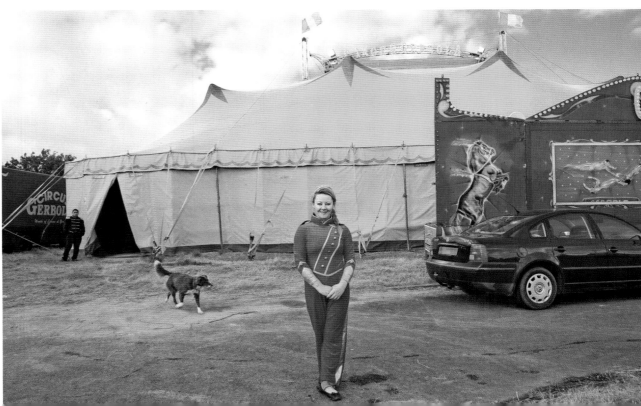

Jaunting Cart Horses

The Gap of Dunloe is one of the most beautiful places in Ireland. The valley gradually narrows along the couple of miles of road from Kate Kearney's Cottage to the Gap. The road is generally quiet and the occasional traffic on the narrow road is mainly comprised of hikers, bicycles and horse-drawn carriages. A mile into the valley it is possible to close your eyes and not hear a single sound.

However it's not only the valley that is quiet. On a warm, sunny day in the middle of the tourist season, the car parks were virtually empty. The large area specifically designated for horses beside Kate Kearney's Cottage was also almost empty and there appeared to be no more than half a dozen horse-drawn carriages working. It was apparent that the global recession and a weak dollar were having an adverse impact, particularly in the areas of Ireland reliant on tourism.

Most of the drivers here are locals and some have been taking tourists along this road for most of their working lives. There are currently up to thirty people trying to earn a living bringing people in horse-drawn carriages to, and over, the Gap. Most will only get one trip per day, or maybe two on better days. In previous years and in better times there would have been trains of these carriages bringing tourists up and down the valley.

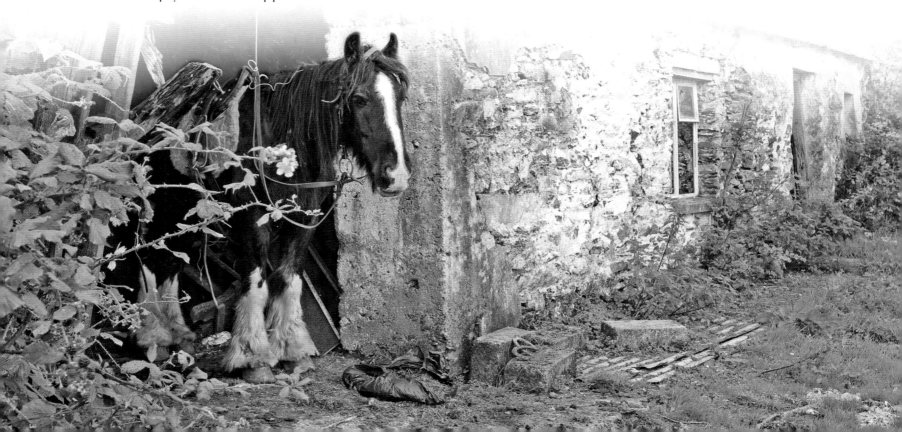

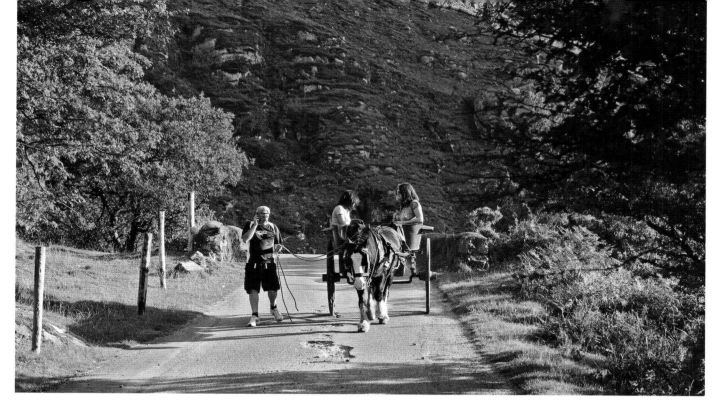

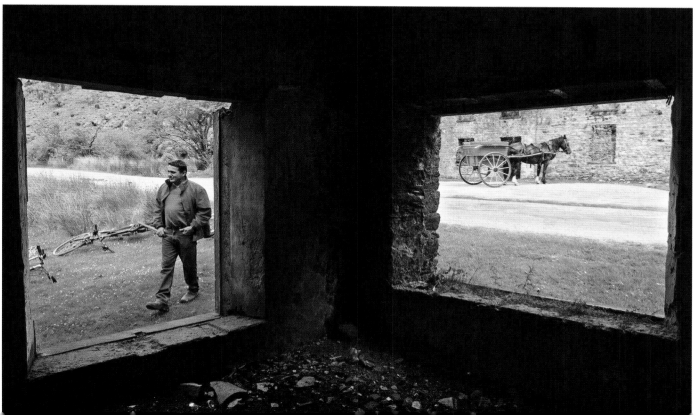

Gypsy Caravans

Located deep in the heart of County Laois, Coolrain is a picturesque little village with small, single-storey, whitewashed houses. The village is a few miles off the former main Dublin to Limerick road and it is not the type of place that would immediately spring to mind as a tourist destination. However, two miles to the west of the village, down a long, narrow road, is one of only half a dozen places left in Ireland where it is possible to hire an old-style gypsy caravan. It is even more surprising to learn that this venture is run by a German couple, Julia and Hans Kuehnle. They initially came to Ireland because of their love of horses and the caravan business is run from their stables and stud farm.

The caravans are about five metres long, two metres wide and sleep up to four people. There are few comforts in them other than the beds and a small kitchenette. The Kuehnles have eighteen caravans available for hire, but business has been tough recently, with bookings at only half the level of previous years. Before each group sets out they are given detailed, hands-on training in caring for the horses and managing the harnesses.

Horses for this type of activity can be hard to source. When the Kuehnles took over the business, some of the horses they inherited had previously been among those last used for pulling coal wagons in Dublin. The horses have to be of a certain build to be able to pull the caravans, and their temperament is very important. Only patient horses can be used, as they may be standing still for long periods of time. Some of the current horses were formally used for pulling carriages in Killarney, but not all of those horses are suitable, as some are too light to pull the heavier caravans.

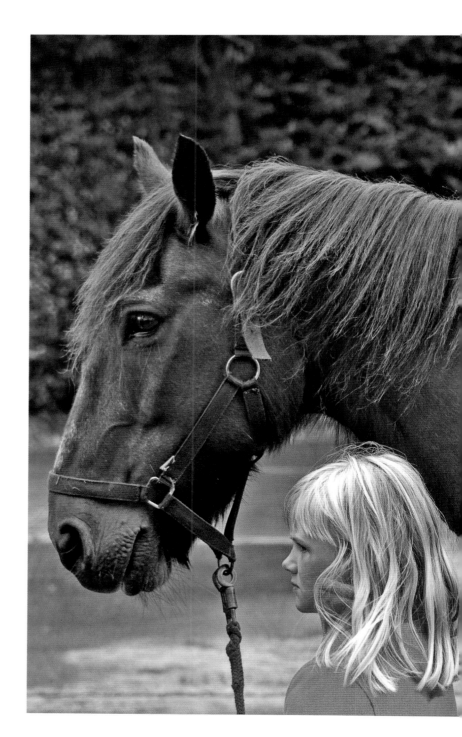

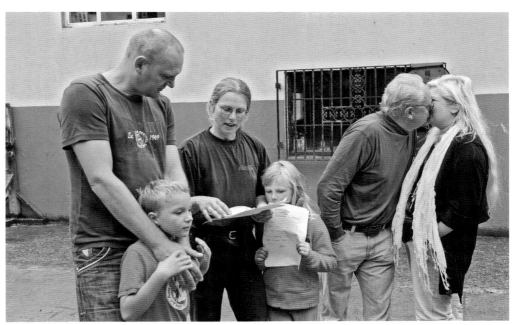

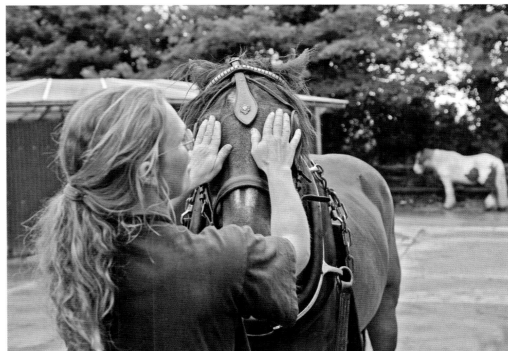

Horse-Drawn Carriages

Many visitors to Dublin take a trip around the city centre in a horse-drawn carriage. The carriages line up on the northern side of St Stephen's Green, just off the top of Grafton Street, and the tours are usually of either half an hour or an hour in duration. During the tour, the driver will impart nuggets of information regarding the history of the capital and the histories of the various buildings, as well as information concerning some of the city's better-known residents. The tours are more personable than the guided bus tours because passengers get one to

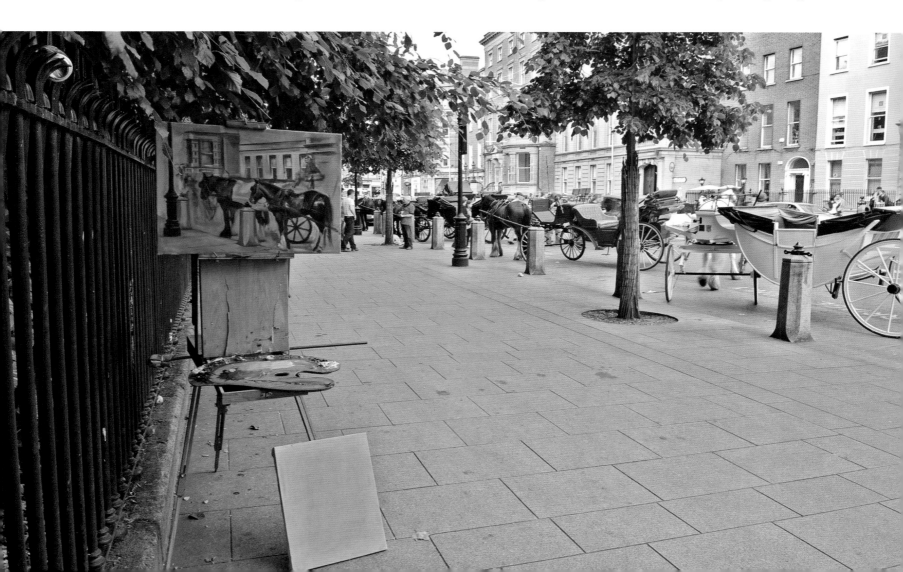

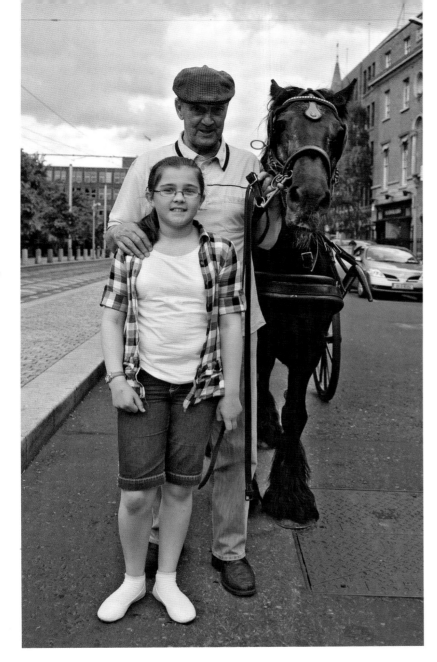

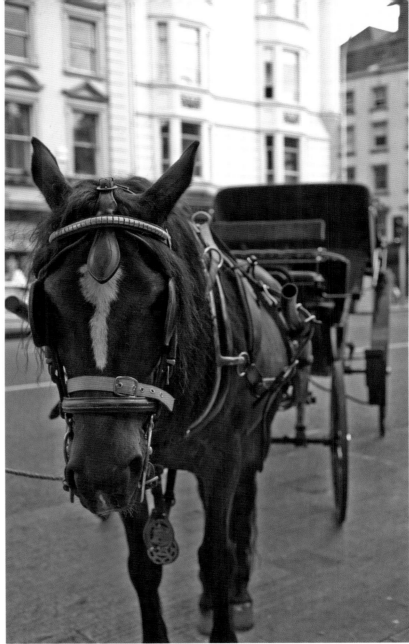

one attention from the driver, who can also turn to talk to the passengers directly.

Molly is a small black pony and she is a quiet, pleasant horse with greying whiskers. She is also well used to people milling around her. At this stage in her life she probably knows the route so well that she could make her own way around the streets without any direction from a driver. All through the day, she will stand uncomplainingly while passersby and tourists are put on her back for photographs.

Stables

There are many stables dotted around the country providing a livery service to the thousands of sports horses in Ireland. One of these, Kinsealy Stables, is located just off the Malahide Road in north county Dublin, directly under the flight path for aeroplanes closing in for landing at the nearby Dublin Airport. From the road, it appears to be an old-style farmhouse with a couple of outbuildings, but after turning into the car park it is apparent that there is a sprawling complex of stables, indoor and outdoor jump courses and tack rooms on the site. John Carey is the proprietor and running the stables is a seven-day-a-week job. At the weekends, the stables are a hive of activity and there are plenty of facilities for grooming the horses. The horses can also be readily exercised on the grounds.

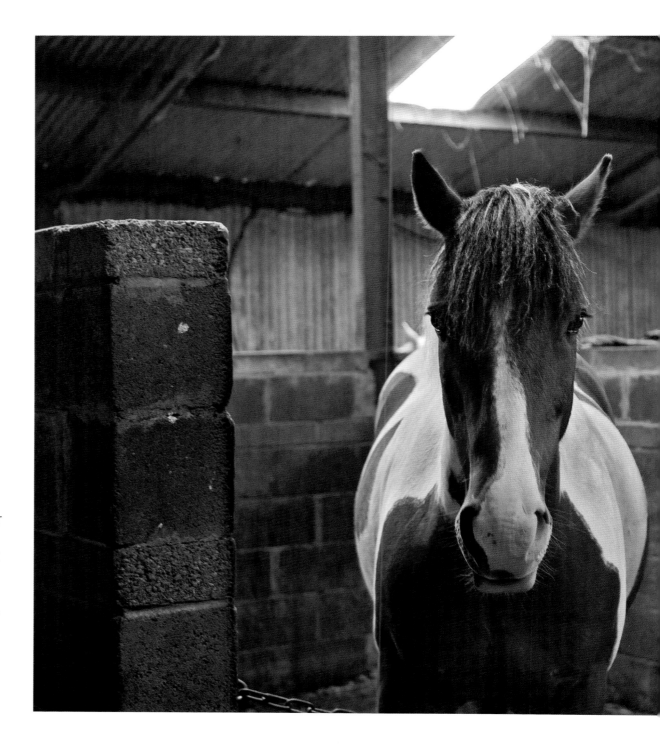

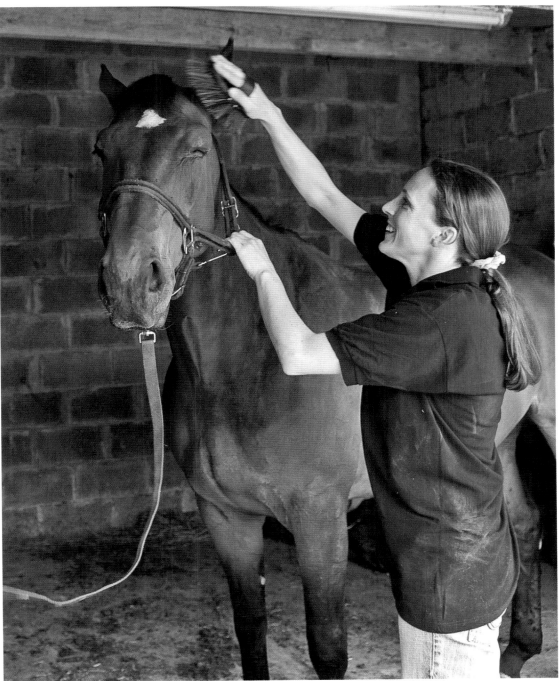

Afterword

My first book, *Images of Fingal – Coast and Castles*, started out as mainly a series of land and seascapes. As it progressed, the scope developed, and the book included, on a small scale, people doing ordinary things in a slightly less-than-ordinary way. Since its publication, more and more of my work has featured ordinary people doing relatively ordinary things within the context of a given story. This wasn't a deliberate or intentional decision on my part; I suppose it was part of my evolution as a photographer.

I have always been a curious and observant people watcher, interested in the mundane while looking for the unusual. Incorporating this into my photography was therefore a natural progression. I am not readily drawn to the obvious drama in photographs from the frontlines and margins of society. I appreciate that images of violence and poverty can pack a powerful punch and that they are important to our understanding of today's world, but most people will never endure or encounter these troubles in a lifetime. There are many worthwhile subject matters well away from the margins of life; it is just a matter of finding them. By their nature, they are more subtle and gentle works, and can offer a kind of redemptive counterbalance to the harsher images from the edge. This work is deliberately placed here. It is a subjective observation of how a cross section of Irish society spends their leisure time (and in some cases how they spend their working time) and the longstanding place the horse has in Irish culture.

Ultimately, this work is about the richness in character and the strength of personality of people. However, watching people interact and observing situations develop is one

thing; it is quite another to make this into a photograph. From a scientific perspective, a photograph is simply an output when reflected light is captured on a photosensitive material. From a human perspective, lifting a camera and taking someone's photograph can be invasive. Each time there is a trade-off to be considered, between asking someone if you may take their photograph (with the possibility that when you do, a subject with a self-conscious look and a plastic smile will present themselves) and taking a more authentic photograph, when the subject is either unaware, just aware or is comfortable with your presence. In most cases it is a judgement call, but I always try to be sensitive to the person I'm photographing. None of the people photographed in this book have been posed by me. This is how they are and how they appear to the world. In this work it was my clear intention to show both the contrasts and the comparisons between the different strands of people involved in this great Irish tradition.

I am generally not inclined to publish information on equipment or settings. Ken Rockwell observed that 'photography is the power of observation, not the application of technology'. Put more bluntly, buying a Nikon doesn't make you a photographer; it makes you a Nikon owner. The only important thing is the final collection of images. In this regard, I hope that I have succeeded in capturing some of the colour and a flavour of the gentle eccentricity of this uniquely Irish story, and that you enjoy the results.

About the Author

David O'Flynn is married to Helen, has two children, Aoife and Maeve, and lives in north county Dublin. He has had a number of solo exhibitions, undertaken commissions (both for display and for publication), and his first book, *Images of Fingal – Coast and Castles*, was published in 2007.

His work can viewed at www.clix.ie

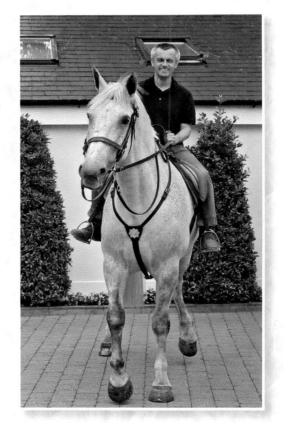

Author photographed on Lir, one of the horses of the Garda Mounted Unit, by Nives Caplice.